THE NEW
ACRYLICS

RHENI TAUCHID

THE NEW ACRYLICS

COMPLETE GUIDE TO THE NEW GENERATION OF ACRYLIC PAINTS

WATSON-GUPTILL PUBLICATIONS/NEW YORK

Executive Editor: Candace Raney
Project Editor: Anne McNamara
Designer: Areta Buk/Thumb Print
Senior Production Manager: Ellen Greene
Photography by Jonathan Sugarman
Photo Styling by Grace Paulionis

First published in 2005 by Watson-Guptill Publications,
Crown Publishing Group,
A division of Random House Inc., New york
www.crownpublishing.com
www.watsonguptill.com

Library of Congress Cataloging-in-Publication Data

Tauchid, Rheni.
 The new acrylics : complete guide to the new generation of acrylic
paints / by Rheni Tauchid.
 p. cm.
 Includes bibliographical references and index.
 ISBN 0-8230-3159-4 (pb)
 1. Acrylic painting—Technique. 2. Artists' materials. I. Title.
 ND1535.T385 2004
 751.4'26—dc22

 2004017867

Manufactured in Malaysia

First printing 2005

9 / 11 10

acknowledgments

THE IDEAL WAY to embark on a project touting the benefits of the new generation of acrylic paints is to work with materials that represent the cutting-edge in acrylic paint technology. The projects, examples, and artwork throughout this book have been produced with Tri-Art finest quality acrylic colors and mediums. Tri-Art Manufacturing Incorporated's generous contribution of the acrylic products used in the photographs and for the production of projects within this book were invaluable. A profound and heartfelt gratitude to everyone at Tri-Art who contributed their time, knowledge, and expertise to this project, in particular Stephen Ginsberg, Mike Janssens, and Celine Tauchid.

Thank you to Candace Raney at Watson-Guptill for allowing me this singular opportunity, and to my terrific editor, Anne McNamara, for her enthusiasm, professionalism, and patience. And thanks to Areta Buk for her skillful layout and design.

Many thanks to Allison Murray and Barbara Klempan at the Queen's University Art conservation department in Kingston, and graduate Marie-Eve Thibeault for their candid advice, research, and information.

Thanks to the staff and directors at Woolfitt's and Wallack's Kingston for their help. And to each of the artists who contributed their fine artwork to beautify this book, I thank you so much.

During the compilation and writing of this book I have been especially fortunate to have the support from my fabulous friends and family with childcare, time management, and moral support. I thank you all wholeheartedly. Thanks as well to those special few who took the time to read, edit, and critique the various stages of the text.

To my photographer, graphic designer, and friend Jonathan Sugarman, who has been an instrumental part in the production of this book and has created photographs that stand on their own as works of art, thank you. My vision for this project was further inspired and realized through the elegant styling of Grace Paulionis—thanks girl.

A very special thanks to my husband, Stephen Ginsberg, for his tremendous support, love, and endurance throughout this project and our life adventure, and to my daughter and stepsons for their patience and great love.

The original painting tool.

about the author

Author *Rheni Tauchid* studied fine art at Queen's University in Kingston, Ontario. She is a member of the product development team at Tri-Art Manufacturing, Inc., a manufacturer of acrylic paints and mediums based in Kingston, Ontario. Rheni has experimented with a broad range of acrylic products and has conducted workshops and demonstrations throughout the United States and Canada.

Photographer *Jonathan Sugarman* teaches the Photography program at St. Lawrence College in Kingston, Ontario. He also runs his own graphic design and photography business, Sugarman Design, and works as a freelance photographer/photojournalist. The photos for this book were captured with a Canon digital SLR and edited in his Kingston studio.

contents

chapter 3: about color 46

chapter 4: acrylic mediums 60

We are fortunate right now to be witnessing the emergence of a new paint superpower.

introduction

IN AN AGE when clothing and hairstyles are unisex, stores offer one-stop shopping, restaurants serve world cuisine, and music crosses and blends all cultural and stylistic boundaries, acrylics shine as the do-it-all-paints, the only stuff you really need. Acrylics are the medium of our age, when all that we know is being thrown into a constant state of flux by the accelerated evolution of our inventions. Just as they revolutionized western art in the 1960s, acrylic paints are riding a continuous upward mobility trend as advances in pigment and synthetic resin technology spring ever forward.

Art trends are leaning toward a redefining of our aesthetic. There will always be painters, but the scope of what is considered to be formal art widens with every passing decade. The new generation of acrylics comes with handling properties explicitly in tune with the new generation of painters. By experimenting with revolutionary techniques, reinventing paint methodology, and learning about the elemental and constantly evolving properties of acrylics, you will be introduced to the endless possibilities of creative expression this new generation of paint can provide.

Acrylics are not what they once were, but are in fact benefiting from an evolutionary process that no other paint medium has had the luxury to experience until now. They are the first truly modern paints, and as such each component of their chemistry continues to ameliorate as our technology and knowledge expands. And acrylics are not static. The rules are not hard and fast or set in stone. Things like fat over lean, light over dark, and the need to always prime your support doesn't limit the acrylic user.

Acrylic paints are holding their own as viable artist-grade media of the highest level. Base chemicals have been brought to their zenith and combined to create luminous, permanent paints of unsurpassed beauty. The clarity of the dried acrylic film is unparalleled in paint media, as technology has developed to produce virtually glass-clear acrylic polymers that will not degrade, yellow, or become brittle over the course of several decades. Bondable to innumerable surfaces, acrylics provide a permanent way to add color and texture to a wide range of materials. Quick-drying and ruthlessly adhesive, they act as the ideal binder, glue, and sealant when incorporating foreign materials into a composition. More mediums are being formulated to encourage the marriage of acrylics to other art media, while advances in pigment production are causing color charts the world over to bust at the seams, offering artists an incredibly wide array of chroma.

With the new acrylics, we have the luxury of producing enduring works of art using the very

latest in chemical invention, all within the comfort of our own homes and studios. Gone is the need for artists to employ apprentices to spend hours grinding and preparing pigments—everything we need is at our fingertips. Painters need no longer become ill or be driven mad by lead poisoning and toxic fumes, and our kids can paint without threat to their health (though maybe to their wardrobes).

They've been around for over fifty years, make up over 60 percent of all artists' paints sold in North America today, and the longer they are around, the better they become. The days when most people equated paint exclusively with oil paints and watercolors are over. Artists' acrylic paints are boldly flowing and splashing their way with resounding force into the new millennium.

Developments in the pigment industry alone have given acrylics a remarkably permanent and abundant palette. And just as colors are being developed, each of the chemical components is also being enhanced.

THE LANGUAGE OF ACRYLICS

Don't let unfamiliarity with the new, discomfort with change, and the uncertainty of reinventing your tried and true painting style all stand in the way of experiencing the rich world being opened up by acrylic media. It is time to get caught up in the rebellion against conformity and tradition in order to break ground and embrace the new order of painting. This is the stuff of revolution.

what are artist acrylic paints?

THOSE WHO PAINT, those who teach painting, and those who are learning to paint are all looking for the same thing: a paint that will stand up to just about any task it is given. In acrylics, artists have found answers to many problems left unaddressed by other media.

These timely paints are long-lasting, non-toxic, and environmentally friendly in their production. Through the virtue of their chemical makeup and handling properties, they have become the perfect medium for the new generation of artists and artisans. Here are some of the reasons why acrylics have attained the status of being the most widely used paints:

Adhesive to multiple surfaces: Acrylics can be applied to innumerable diverse substrates, including acrylic paint itself.

Clarity of resin: Acrylic resin is second only to glass when it comes to clarity. The transparency of the acrylic polymer film allows pigment characteristics and intensity to radiate through.

Variety of format: From pasty and thick, to water-thin, these paints can be applied in a huge variety of ways with myriad tools. Not only are the colors available in varying viscosities and pigment loads, but the range of acrylic mediums which accompany the lines are a group that is as expansive as it is diverse. More mediums and additives are being introduced each year, and this trend shows no sign of slowing.

Compatible with multiple and varied art materials: The omnifarious master of mixed media, acrylics blend beautifully with innumerable materials.

Impervious to many liquids: Acrylics seal and provide protection against wet materials and inclement weather. Dried acrylic will not be reactivated when painted over with water- or oil-based materials. (Solvent-based materials are the exception to this rule.)

Resistant to UV light: Acrylic colors and mediums are not compromised by exposure to ultraviolet light and are therefore well suited to outdoor applications or for artwork intended for display in strongly lit environments.

Malleable: From issues of storage and transportation to building soft sculptures and painting on soft substrates, the flexible nature of acrylics greatly increases the range of application possibilities.

Water-based: Low odor and easy clean-up make acrylic paints an obvious choice for painting in public places or in small personal ones.

ACRYLICS ARE MADE UP of three basic elements. The first is the acrylic polymer emulsion itself—a water-thin, milky solution derived from polymerized acrylic resin dispersed in water. The second ingredient is color. Dried pigment is dispersed in deionized water creating the pigment dispersion. The third component is comprised of several chemicals—freeze/thaw stabilizer, surfactant, biocide, fungicide, thickener, defoamer, and pH stabilizer—that control the viscosity, stability, and longevity of the product. All of these elements combine in specific quantities to form what we know of as acrylic paint.

High viscosity Naphthol red medium.

elements of acrylic paint

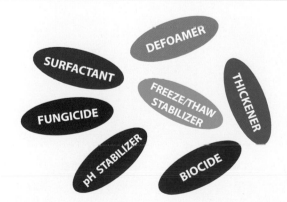

Acrylic polymer emulsion
+ **Dispersed pigment**
+ **Freeze/thaw stabilizer**
+ **Surfactant**
+ **Biocide**
+ **Fungicide**
+ **Thickener**
+ **Defoamer**
+ **pH stabilizer**

Acrylic paint

Rather than sag and level out, the new generation of high viscosity colors has the unique capability of holding sharp peaks several inches in height. The high solids content in the paint formulation allows for lower shrinkage, leaving the structure generated by the painting tools virtually unchanged as the acrylic dries.

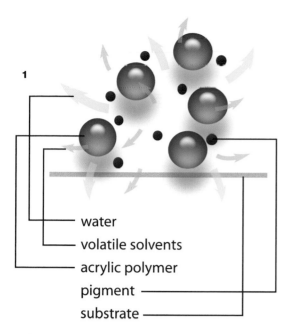

1

— water
— volatile solvents
— acrylic polymer
— pigment
— substrate

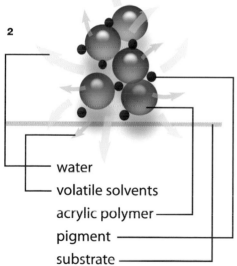

2

— water
— volatile solvents
— acrylic polymer
— pigment
— substrate

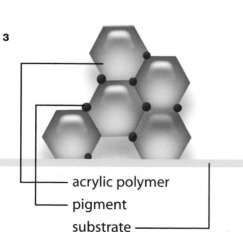

3

— acrylic polymer
— pigment
— substrate

Quinacridone magenta liquid.

1 One thing that distinguishes acrylic emulsion paints from oil paints is the way they dry. Oil paints dry through a continuous chemical reaction. What this means is that they continue to dry indefinitely when they are in contact with the air. The acrylic polymers are already fully formed in the wet emulsion, and the pigment particles are suspended in the liquid. As the paint dries, all of the volatile solvents in the paint evaporate from the film and through the substrate by capillary action. (A volatile solvent is a substance that at normal temperatures and pressures evaporates readily from a solid or liquid to a vapor.)

2 As the solvents, predominantly water, exit the film, the acrylic polymers drift closer to each other. At this point, they begin to form bonds, corralling the pigment particles. Once the water has evaporated, the paint will feel dry to the touch, however there is one more step to curing the acrylic film.

3 The remaining solvents, comprised mainly of freeze/thaw stabilizer (propylene glycol), coalescing agents, and defoamers, evaporate from the film at a much slower rate. When these are no longer present, the polymers form a honeycomb-like grid, and the previously round polymer molecule takes on a hexagonal shape. The micro fissures left by the exiting solvents give the acrylic its mildly porous quality.

acrylic paint production

THE FINEST quality pigments are used in the production of artist-grade acrylic colors. To begin, powdered pigments are dispersed into water. Through varying methods (depending on the manufacturer's equipment), the hydrophobic pigment is forced into a homogenous mixture with deionized water. The water molecules surround the pigment, resulting in the formation of an aqueous pigment dispersion, which is then ready to be added to the acrylic paint base. In the mixing vessel, a specially machined stainless steel blade spins the mixture together. The blade stirs the paint while the sides of the vessel are continuously scraped to prevent the edges from drying out and to ensure uniform mixing. The blades are carefully machined to mix varying paint formats and to accommodate different mixing bucket sizes. Then, the additional ingredients are added to the mix: surfactant, defoamer, thickener, freeze/thaw stabilizer, fungicide, pH stabilizer, and biocide. Each of these components is essential to the stability, longevity

flow chart of acrylic paint production

Pigment

Acrylic polymer resin and additional ingredients

Pigment dispersing in water

Aqueous dispersion being mixed into acrylic base

Thickened paint

and bacterial resistance of the finished product. Once the paint has thickened and the ingredients are fully merged, it is inspected by quality control before being packaged. The quality control procedures generally include comparing the new paint with the standard (physical sample) for color concentration, viscosity, and pH balance.

Once approved, the paint is poured into large stainless steel hoppers attached to the tubing and jarring machinery. The air- or machine-driven mechanism pushes the paint from the hopper into plastic jars, or metal or plastic tubes. (Only small quantities of high viscosity paint are packaged in tubes; quantities upwards of 4 or 5 fluid ounces are packaged in jars and pails.) Then, the machine's many jaws crimp the ends tightly to seal the tubes. All of the machinery and tools used in the packaging of acrylics are carefully washed and sanitized prior to filling to prevent contamination from color to color. Once packaged and sealed, most acrylics will have a shelf life of six to ten years or longer.

Tubing color

High viscosity paint in tubes

Color being poured into hopper

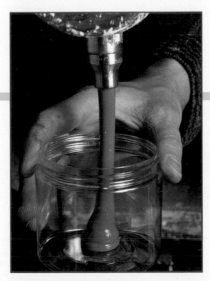
Color being filled into jar

High viscosity paint in jar

artist- vs. student-grade acrylics

THERE ARE general misconceptions about the limitations of acrylics resulting from familiarity with only student or bargain quality acrylics. Just as there is a wide gulf between early acrylics and modern varieties, there is an equally large discrepancy between artist quality and student quality paints. The validity of one cannot be judged by having only experienced the other.

Artist-grade acrylics are the top of the line paints, while student acrylics are designed to be an economical alternative. Artist acrylics have a much higher pigment load, finer quality raw materials, and contain little or no fillers. The higher cost of artist-grade paints is deter-mined by several factors: quantity of pigment; quality of raw materials; and packaging, labeling, and additional literature.

The pigment, being the most expensive component of the paint, is present in a very large quantity in artist-grade acrylics. What this means on a practical level is that you get more color for your dollar. The more pigment there is, the further you can stretch your colors. Artist-grade

acrylics have very stringent standards to live up to in order to fulfill the requirements of the industry as well as those of the painter. Careful consideration to quality control and superior raw materials ensure artist-grade acrylics an extended shelf life.

Student and craft paints can offer the similar handling characteristics as their high-end counterparts without all the bells and whistles, and with a few marked limitations. This grade of paint has a much lighter pigment load, often less than half than that of its high-end counterpart. In some cases, student paints are manufactured with less permanent pigments and are bulked up with fillers. Some manufac-turers combine the acrylic emulsion with vinyl or styrene to keep the cost down. These alter-native components are more yellowing, more brittle, and less permanent than a pure acrylic emulsion. Student-grade acrylics also have a tendency to appear more matte when dry, and because of the lower pigment load, the wet to dry color shift is more apparent.

A comparative study of the difference in pigment loading between artist and student (economy) acrylic paints. In each comparison, the swatches displayed are artist quality on the left and student on the right. From left to right: 100% color, 50% color + 50% titanium white artist-grade liquid acrylic, 50% color + 50% gloss medium.

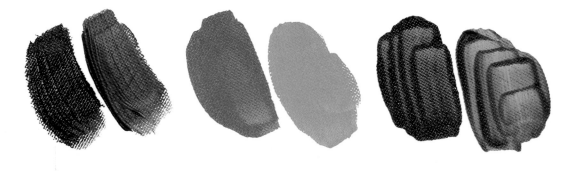

making the grade

Packaged in more substantial, durable packaging, artist-grade paints are more appealing to the consumer. The labeling of artist-grade paints is generally more informative and polished, as is the literature and hand-painted color charts that customarily accompany the product. All of these factors combine to offer discerning artists a quality commodity.

What are the primary characteristics of acrylic paint?

What distinguishes one paint type from another is its binder, the glue or substance that carries the pigment. In the case of oil paints the binder is oil, watercolors are bound by gum Arabic, and acrylic paints are bound with acrylic polymer emulsion.

Acrylics are water-based, synthetic resin paints. They are quick-drying and water-fast when dry. They are available in a variety of viscosity formats, are highly adhesive, and are virtually non-toxic.

Acrylic paint has good resistance to mildew and environmental damage. The acrylic emulsion dries clear, leaving a film that is durable, flexible, and non-yellowing. The wet paint can have a very low odor and clean up of tools is easily accomplished with water and mild soap.

How are pigments added to the acrylic binder?

Pigments are pre-manufactured by large chemical companies. They come in powdered form, which is ground to a specific particle size that differs with each pigment. In order for the pigment to be mixed properly into an acrylic base, it must first be dispersed into water. In their pure form, powdered pigments are hydrophobic, which means they will not mix readily with water. There are several ways to wet out the pigment, forcing the powder and water together so that a water molecule surrounds each particle. Proper wetting out, through grinding, aids in further developing the color. The resulting, homogeneous mixture is called an *aqueous dispersion.* The grinding process can take several hours to a full week, depending on the individual pigment.

What is acrylic polymer emulsion?

Acrylic polymer emulsion is derived from petroleum or natural gas. The water-thin, milky solution is obtained from polymerized acrylic resin dispersed in water. This material, when devoid of pigment, dries very clear and glossy. The dried film is highly resistant to water and is extremely flexible.

Are acrylic paints permanent art materials?

Artist acrylic paints are permanent on many levels. They are manufactured to conform to ASTM (American Society for Testing and Materials) standards. In artist-grade paints, only pigments that have a lightfastness rating of I (excellent) or II (very good), in accordance to ASTM standards, are used.

The resin itself is fully formed in the wet paint and forms permanent bonds as the paint dries. The dried acrylic film is very flexible and tough, and will not yellow significantly over time. Acrylic is highly adhesive and forms a very strong bond to its support, and to itself. Once bonded, it cannot be removed without the use of powerful solvents or highly abrasive materials.

Why do the wet acrylic colors appear lighter than dry acrylics?

One of the stumbling blocks for strangers to the acrylic realm is the slight color shift that occurs when the paint goes from wet to dry. The degree of change depends largely on the amount of pigment in the acrylic itself. When wet, the acrylic emulsion has a white appearance because of the water it contains. The way that light travels through the water causes it to appear opaque. As the water evaporates, the paint film clarifies, leaving the pigment to be fully developed. Artist-quality paints contain a significantly larger quantity of pigment than the student or economy varieties. The higher the pigment load, the smaller the color shifts between the wet and dry stage. Lower quality paints also tend to contain more water and fillers, opacifying the

Liquid acrylics ooze smoothly from their package, having enough cohesion to form an even pool of color. Liquid format paints pass through a very fine filter before being pumped into the bottles.

wet paint further. Matting agents and fillers will also cause the wet paint to have a more bleached-out cast, though this will also decrease significantly when the paint is dry. If you have concerns about matching a tone exactly, the best way to work is with a test area and a blow-dryer.

Can I mix my acrylics with other paint types?

Acrylics will perform best when used in conjunction with other acrylic media. They can be used in combination with other water-based paints such as watercolors, gouache, poster paints, and water-based inks, although it is prudent to test each product combination thoroughly. Acrylics should not be mixed with oil- or wax-based products. Mixing acrylic brands is generally acceptable; however, as each manufacturer uses a unique recipe, there can be a potential for incompatibility.

How long do acrylics take to dry?

Acrylics dry through the process of evaporation. Various components of the wet paint must first evaporate in order for the paint to dry. The first is water, which escapes through capillary action both into the air and through the support (if the support is porous). The water will evaporate fairly quickly, leaving the paint dry to the touch. (Thin paint films will dry to the touch within a few minutes, while thicker quantities will need several hours.)

While the paint may feel dry, it will not be fully cured until the other volatile substances have evaporated. Other solvents, such as propylene glycol, defoamers, and coalescing agents take considerably longer to withdraw from the paint. Until it has fully cured, the acrylic is sensitive to abrasion, water absorption, and pressure. Thin paint films will be thoroughly cured within a few days, whereas thicker applications can take up to several months to become inert.

How porous is dried acrylic paint?

As the solvents exit the paint film they leave behind microscopic pores. These pores allow for future layers of paint or art media to form a substantial bond.

How can you tell the difference between a touch-dry and fully cured acrylic?

There is little visible difference between the two states, and it is more a matter of being

Assorted ceramic beads used in the dispersion of powdered pigments into deionized water.

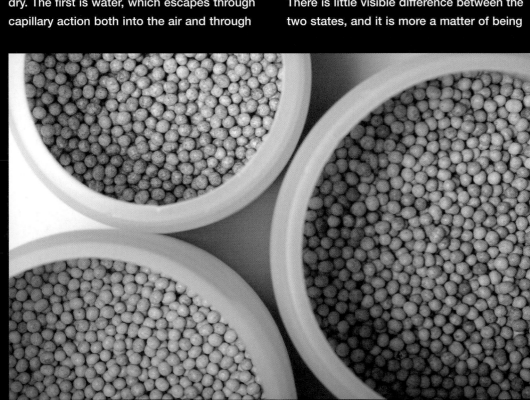

aware of the amount of time that has passed since the initial application.

A fully cured acrylic will have little to no trace of milkiness and the color will have visibly darkened compared to the wet state (this is more obvious in mixes than with pure, undiluted colors). The paint film will be firm and resistant to water. (Keep in mind that unvarnished acrylics will remain slightly tacky even when fully cured and this slight stickiness should not be mistaken for dampness.)

Curing reveals the complexity of color mixtures and paint layers, and it is one of the most exciting aspects of painting in this medium. As the paint cures, details will become visible in the painting; colors will deepen and visibly intensify. While the transition is immediately obvious, more subtle transformations will emerge over a period of months.

Will the ambient temperature and humidity of the working environment affect the behavior of the paint?
Not only do temperature and humidity affect acrylics, it is crucial to keep them in mind when working with the paint. As the acrylics dry through evaporation, they will set more quickly in dry, hot environments, and be more sluggish in a humid setting. A hairdryer on its low setting can be very helpful for coaxing the paint to dry faster.

Can I paint over partially dried acrylic?
Painting over partially dried acrylics is a tricky business and can create some mixed results. When a thin acrylic layer is dry to the touch, more layers can be applied with no adverse effect. The new layers will not reactivate the underlying paint, and luminous glazes can be accomplished using this method. When layering in thicker quantities, it is essential that the paint be cured. If it is not, water and other solvents can become trapped in the partially dried paint, clouding the acrylic film.

Applying a wash over semi-dried paint can pull out the remaining solvents prematurely,

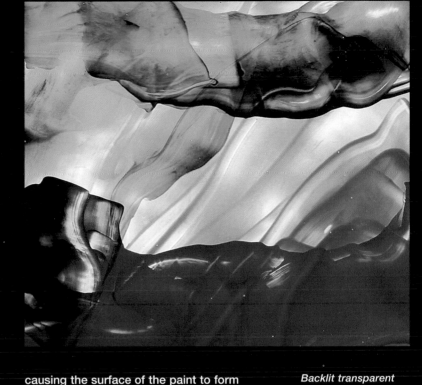

causing the surface of the paint to form craters, lose clarity, or dry to a more matte finish. The most prudent approach to layering and over-painting is to give the initial coat ample time to dry before applying more paint.

How resistant is acrylic paint to UV light?
In order to make it into the upper echelons of the acrylic family, each color must be made up of pigments with a lightfastness rating of very good to excellent, both full strength and in a tint.

Many pigments used today are as extraordinarily stable as they are diverse. The acrylic polymer emulsion itself is also quite resistant to the effects of prolonged exposure to UV light. The film will remain clear and virtually non-yellowing.

shelf life

Unopened paint in its original packaging can have a shelf life of more than a decade if it is kept in a temperate environment. Store premixed paint in clean plastic containers with lids. Mark the lids with a dab of the color mix for easy identification.

Backlit transparent glazes in yellow, red, blue, and green are beautifully showcased on a transparent surface.

the acrylic format

NOWADAYS, acrylics come in so many formats, making a choice can sometimes be a little confusing. The key to finding the right acrylics for you is to determine how you will be using them, on what and with what types of mediums.

The advantage to having ready-made paints of the right viscosity available for your specific needs is that it cuts down on the amount of time used to thin down or bulk up the paints. Dilution, with either water or mediums, means sacrificing a certain amount of color intensity. When a painting calls for maximum chroma, acrylics can offer a heavy load of pigments in viscous to watery consistencies. Each of the components in the acrylic line-up is compatible with the others, in any dilution, and for the most part can be mixed from brand to brand as well.

high viscosity acrylics

High viscosity acrylics are the front-runners in the acrylic color family, and the ones most commonly stocked in art supply stores. This is in part a consequence of their history, rather than their practicality. Historically, acrylics were an alternative to oil-based paints, and therefore were designed to mimic them in appearance and consistency, hence their pasty texture and handling properties. Now that acrylic materials have secured a place for themselves as more than stand-in paints, they are no longer limited to that format.

High viscosity acrylics are heavy bodied, paste-like colors that hold a great deal of texture and detail. In spite of their superior peak-holding capabilities, these colors have a smooth, buttery consistency that is easy to manipulate with anything from a very soft brush to a rigid palette knife.

High viscosity colors are capable of holding a mountain range of crisp peaks that will maintain their shape when dry.

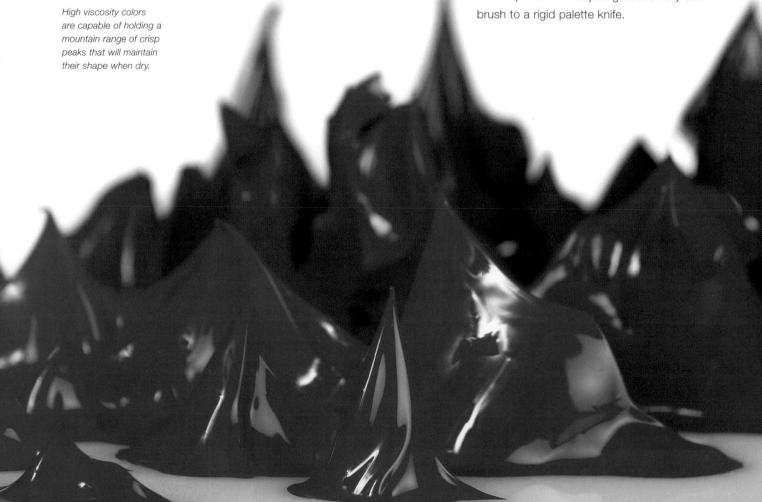

Because of their mass, these thick colors will stay wet longer on the palette and they can be used for several days if the palette is protected with an airtight seal. High viscosity colors are suitable for any support that is compatible with water-based paints.

liquid acrylics

The natural state of the acrylic polymer emulsion is a liquid one. The wet acrylic, before the pigment and necessary constituents have been added, has the appearance and consistency of skim milk. Liquid acrylics therefore are the "purest" form of acrylic paints. Gloriously brimming with pigment, they can be splattered, swished, or dripped into your painting. The flow of liquid acrylics allows for more control and longer brush strokes. Painting long, flat, uniform strokes of color is one of the strengths of this format. The intense color load combined with the smooth and lush texture encourages a la prima and wet-in-wet techniques.

The common conception that liquid acrylics are a diluted form of the high viscosity paints is erroneous. At the artist-quality level, most liquid acrylics have the same pigment load as their high viscosity counterparts, and are priced to reflect that. There is a small amount of thickener added to liquid acrylic colors for ease of application. This is necessary to keep the paint from dripping and sagging when brushed onto a vertical surface.

Liquid colors are pourable and generally have enough body to achieve soft textures and show brush stroke. As they can be applied drop by drop, these are the best choice to use when tinting acrylic mediums. The packaging of this format provides painters with a more precise way to measure and control color mixing and tinting. In addition, working with liquid acrylics directly from the bottle will result in less excess paint drying on your palette.

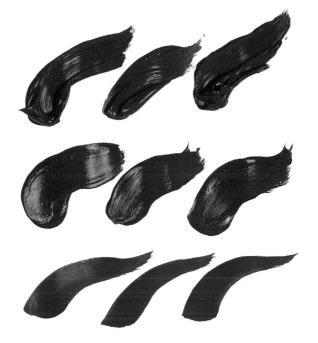

Artist-grade colors are available in varying formats. The difference between these swatches of Naphthol red is only the viscosity. Pigment load, gloss factor, and relative transparency are not affected by the color format.

BELOW: *Indian Yellow liquid acrylic paint.*

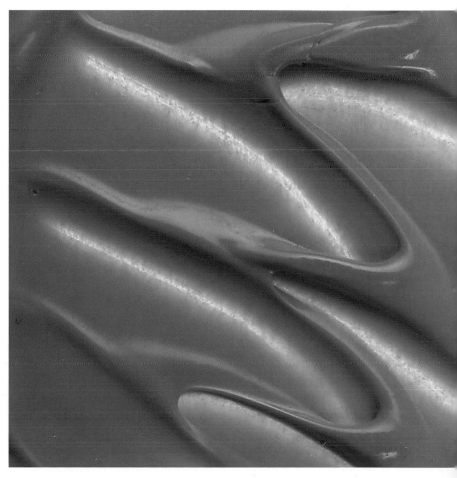

airbrush acrylics and acrylic inks

Although intended for a variety of different application techniques, airbrush acrylics and acrylic inks share some basic properties. They are both almost water-thin, are passed through a 1000-micron mesh filter to ensure the best pigment dispersion, have high pigment loading, and share the permanent qualities of other acrylics.

Acrylic inks allow for exploration off the canvas and onto more supple supports. They are a great choice for fine detailing and loose, fluid techniques. When thinned with a bit of water, they are a fabulous choice for fabric painting and printing.

The relative viscosity of different brands may fluctuate, but for the most part these colors have a slight thickness that is necessary to keep the pigment from settling in the jar. There are various additives designed to increase the flow of this acrylic format for pen use, and to decrease clogging in an airbrush.

Acrylic inks are available in a variety of transparent to opaque colors. They can be thinned with an acrylic flow release agent to keep them wet and usable in steel nib and mechanical pens for several hours. The palette of colors in these paint formats is generally more limited than liquid or high viscosity colors. One of the determining factors for this is that some pigments, such as Cadmiums, pose a small toxic threat when sprayed, and are therefore not included in the selection. Other pigments are too heavy or coarse to stay suspended in the thin emulsion or to pass through the fine filters.

hot stuff

Flammability is not an issue when working with acrylics in your home or studio. Both the acrylic polymer resin and the aqueous pigment dispersions are considered non-flammable. In both wet and dry states, acrylic paints are neither corrosive nor flammable. If there are concerns with acrylic applications in unusual or high-risk scenarios, the best precaution is to get Materials Safety Data Sheets (MSDS) about the material. This information should be readily available by request from the acrylic paint manufacturer. Bear in mind, though, that dried acrylic film will become more malleable and sticky when exposed to high temperatures. The ideal temperature for acrylics is around 60 degrees Fahrenheit (15 degrees Celsius).

Ink format acrylic colors range from a slightly thickened to extremely watery consistency. Those inks colored with pure pigments have a tendency to be thicker, to keep the pigment suspended in the acrylic emulsion without settling to the bottom of the jar. In this format, even heavier pigments will remain fully mixed.

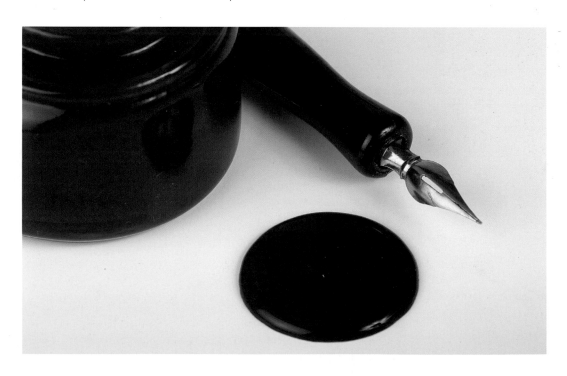

What's the difference between acrylic paint and acrylic ink?
Not very much, actually. Artist-quality acrylic ink is the long name for really thin acrylic paint. The viscosity of acrylic inks range from very thin to something similar to slightly thickened water. Acrylic inks are formulated to work with a paintbrush, airbrush, or pen.

What's the difference between acrylic inks and other inks?
The majority of artists inks are shellac-, gum Arabic-, or acrylic solution–based. Permanent acrylic inks are formulated using a 100% acrylic emulsion. What this means is that they will dry permanent, waterfast, and flexible. The other main difference is the color. Traditional inks are colored with dyes, which are generally not light-stable. Acrylic ink manufacturers use artist-quality pigments throughout the line with excellent or very good lightfastness ratings.

Can I use these inks with my acrylic paints?
Most definitely. The inks that are acrylic emulsion based can be used with high viscosity, liquid, or airbrush colors. They are generally compatible with the vast majority of other acrylic brands and formats.

What surfaces can I use these on?
Any surface that you would paint regular acrylics onto: paper, fabric, wood, clay . . . virtually any non-greasy or non-oily surface.

Can I mix them with my acrylic mediums?
Absolutely. Extend, thicken, or add texture to your inks just as you would other acrylic formats. The best mediums for extending inks are airbrush or low-viscosity polymer mediums, which have a water-like consistency. Flow release medium is also an essential inking medium.

What is Flow Release? Why do I need it and how much of it do I add?
Flow release is the fundamental partner to acrylic inks when using any sort of pen (steel nib, calligraphy, or technical) or airbrush on a porous surface. It should never be used when you are painting with a brush. Flow release is an intensely strong retarder. It greatly increases the open time, or usable time, of the acrylic inks while enhancing the ease of flow through pens and airbrushes. It also prevents the ink from clogging on the tips of pens and air-guns, and makes them easier to clean. The flow release to ink ratio is ideally somewhere between 1:1 and 1:2. The best way to judge the ratio is by adding the flow release to the ink a few drops at a time until the consistency feels right. With the correct proportion the ink will flow smoothly and you will find that even in an open container the ink will remain wet and workable for several hours. Once dry the ink will be permanent.

Why should I not use Flow Release when painting with a brush?
Adding flow release to the ink makes it dry very, very slowly. When applied to a surface with a brush, the ink will remain tacky for hours or even days, but will not be resoluble or workable during that drying period. When sprayed on in a thin film or drawn on with a pen, the ink film or line is thin enough to absorb into the paper or other porous surface.

When would I use these inks?
Acrylic inks are ideal for all inking projects. Acrylic inks also make fabulous fabric paints. They can be used straight from the jar or diluted with water to create designs on, or to stain, most fabrics and leathers. They do not require any heat-setting, but should cure for a week before washing.

Arylide yellow acrylic ink.

specialty acrylics

WITH THE PIGMENT and coatings industry devoted to coming up with more and better colors and acrylic polymers, there is a wealth of possibility for the future of artist acrylic formats. The following are just two examples of some recent developments.

resoluble acrylics

One type of specialty acrylic to appear in recent years is resoluble acrylic paint. This technology is quite new, and as yet this type of acrylic is only available in an educational level paint format. This paint is made with a pure acrylic emulsion that can be reactivated with water after it has dried. The pigment load is low, keeping the paint economically priced and less staining.

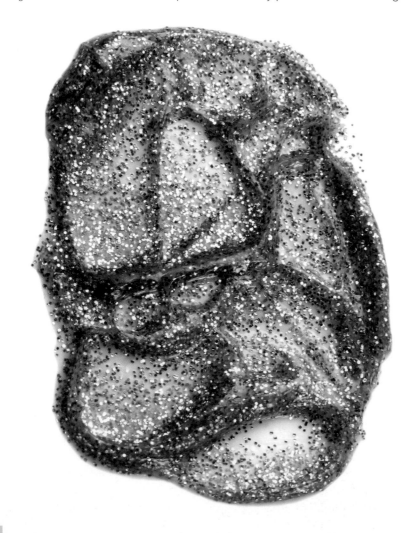

The benefits of this type of paint are huge. Instead of having to purchase watercolors, gouache, acrylics, and printing inks, educators can use a resoluble acrylic to satisfy each type of application. Being made with acrylic emulsion, they are compatible with most acrylic mediums and can therefore be made permanent, thick, glossy, or matte. They can be used to color printing mediums or combined with a liquid polymer medium to create a beginners' fabric paint. And using a resoluble acrylic as a beginners' airbrush paint makes a great deal of sense, as it can be easily washed out of the airbrush. This paint washes away easily from brushes, palettes, and other tools even after it has been left to dry for several days. The acrylic binder affords these paints a very good shelf life, and the transparency offers brilliant color without chalkiness.

glitter paints

In addition to resoluble paints, there are now Mylar glitter acrylics. This paint may have the look of your average glitter glue, but it is in fact much more. The colored Mylar particles are suspended in a 100% acrylic emulsion base, giving the paint all the attributes of traditional acrylic colors. The colorants themselves are very thin, colored polyester particles; in some cases they can also be a combination of Mylar particles and coated mica. The particles are non-corrosive, flexible, and highly reflective. Some have a holographic optical quality, with each particle reflecting the visible spectrum at different angles.

These colors have a viscosity similar to that of liquid acrylics and are intermixable with all acrylic colors and mediums. Though some may find them ostentatious, they can add a dazzling shimmer when used effectively in a composition.

It was clear to me that a new substance was required which could truly express the undisputed achievements of our Western civilization . . . We have revitalized art and found new visual mysteries of the human psyche . . . we have persevered against the shallow and fashionable art of the day. It would not have been possible without advanced acrylic paints and without our independence of mind.

innovations

ESSENTIALLY, modern acrylic paint is the synthesis of years of scientific and artistic research and development within each aspect of its chemical makeup. As such, they are more resistant, more intense, stronger, and cleaner. Acrylics have come a long way from their modest roots as runny, matte, solvent-based paints. The innovations in the coatings and pigment industries have conspired to form a type of art material that is fully in tune with the changing needs of the modern painter.

acrylic amelioration

So just how different are the acrylics we use today from the acrylics of decades past? The first acrylic paints produced were solvent-, rather than water-based. Yet, despite being somewhat odorous, these quick-drying colors were a revelation to artists of the 1960s. Eventually, water-miscible polymer paints came onto the market. They were chalky, with a relatively low pigment load.

The color selection among early acrylics was fairly limited, but it became gradually less so as demand grew. Then came the need for a medium, other than water, with which to dilute the colors, and thus the first gels were produced. As paint lines bulked up their palette, they also expanded their array of gel and liquid acrylic mediums and additives.

Aside from the primary components of the paint, other agents necessary in their production have also undergone improvements. Anti-bacterial agents are more aggressive than before, and, along with the addition of efficient freeze/thaw stabilizers, they allow for a much longer shelf life. Modern equipment, safety standards, and filtration procedures ensure consistency between batches, resulting in a more pure and refined finished product.

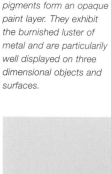

Very fine iridescent pigments form an opaque paint layer. They exhibit the burnished luster of metal and are particularly well displayed on three dimensional objects and surfaces.

longevity

Now that more than half a century has passed since the onset of acrylic production, there is a significant amount of data that will lead to a better understanding of how acrylics age and react under varying circumstances and on diverse supports. Despite the obvious limitations of accurately predicting the impact of time on their stability, research has found that acrylic paints will most likely endure as a permanent medium. The proviso that painters use acrylics as specified by the manufacturer and endorsed by art conservationists will further ensure their longevity.

quality control

The majority of the pigments used in modern acrylic production are synthetically manufactured. Even some mineral colors, such as red and yellow iron oxides, are lab-made. This makes it easier for paint manufacturers to keep the quality consistent and the color uniform from batch to batch. Each aspect of the paint undergoes a rigorous inspection prior to packaging. Tests are conducted for many aspects of the paint, from viscosity and pigment load, to pH balance.

environmental friendliness

Anyone with concerns about the materials they are using should take the time to read the MSDS (Material Safety Data Sheet). These are available by request from the acrylic paint

manufacturers and provide information on the proper procedures for handling or working with a particular substance.

The disposal of paint leftovers is one concern that bears mentioning. In order to avoid contaminating your groundwater, let the remains of your creative endeavors dry thoroughly in their container or palette before putting them in the garbage. Wipe painting tools on old rags or your palette to keep the rinse water clearer.

Practicing informed studio habits is the best way to prevent health and environmental mishaps. Read the label and use the product as it is intended.

Iridescent copper high viscosity paint plus extra coarse nepheline gel on a surface of coarse nepheline gel tinted with Phthalo turquoise and holographic glitter acrylic.

the real hue

The choice of pigments used to produce artist-quality acrylics is governed by two main factors: permanence and popularity. From time to time pigments will be discontinued for various reasons, most of which hinge on their availability, instability, or popularity within markets, such as the automotive and plastics industries. In the case of pigment extinction, manufacturers will generally replace the color with a similar pigment or pigment combination to match the original. If the same name is used, the word "hue" will usually be added to the label.

MATERIALS
AND
EQUIPMENT

Painters embrace the challenges of solving a material, striving to figure out its various possibilities as well as its limitations. This impetus is part of the creative process, and each new generation of artists will inevitably push their predecessors' envelopes.

preparing to paint

FROM CARS TO COMPUTERS, technology is falling over itself trying to keep up with the demand for faster, stronger, higher performance tools and toys. To my mind, acrylic paints fit easily into both categories: tools and toys. In their present state, they exemplify all that modern painters can demand from their material. In their highest quality, they are clear, brilliant substances, capable of much diversity in their application, context, and form. They are at the apex of innovation in the art materials universe.

Here, a traditional printing tool, an acrylic brayer, is used to create intriguing surface texture.

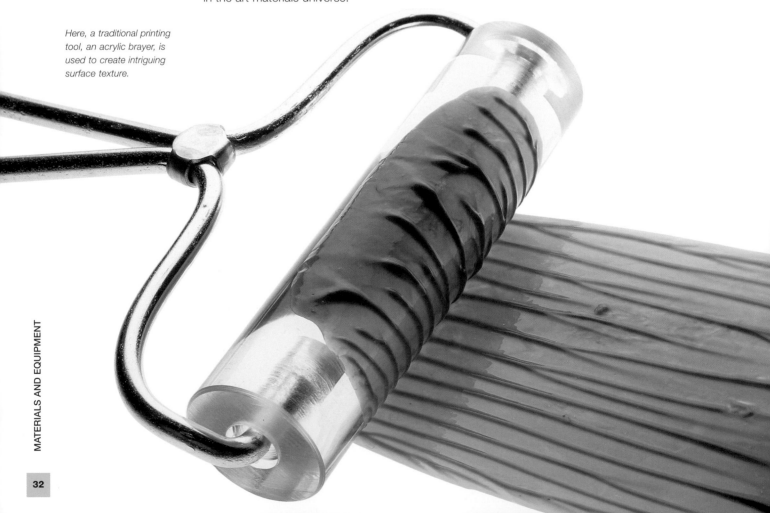

The new acrylics offer artists creative freedom unlike any other painting medium. Aside from paint formats and colors, artists can choose from a variety of supports and application methods. As acrylics can adhere to a wide variety of surfaces, supports can run the gamut from traditional linen canvas to more unusual surfaces, such as metal mesh or rubber foam. Regardless of what support is chosen, it must be prepared to receive the acrylic colors. Once the surface is prepared, the real fun begins as artists can choose from a wide variety of traditional to innovative tools for applying the paints. Being conscious of proper support preparation and proper use of materials are the first steps to creating works that are both beautiful and lasting.

picking the support

Acrylics are able to stick to just about any surface, and are flexible enough to accommodate the shifting of materials like wood and fabric. Artists may choose from a wide variety of supports, from paper, to canvas, to board. Prior to painting, an artist must consider a number of factors in selecting the support, most notably the character of the support chosen and the potential impact it will have on the finished work.

porous and semi-absorbent

The porosity or absorbent character of many materials offer good grappling hooks for the acrylic polymer to hang onto. Highly or semi-porous substrates are the ultimate choice for acrylic technique. The more of a bond formed between the paint and its support, the higher the chances of the artwork's perpetuity.

These are some examples of absorbent substrates: art papers, handmade papers, wood, canvas, linen, miscellaneous woven textiles, properly treated leather and suede, compressed hardboard, MDF (medium density fiberboard), and bisque-fired clay.

non-porous

When using a non-porous support, the surface must first be given some "tooth" to give the paint something to grip onto. For best results, begin by carefully cleaning the surface to remove any oils or grease. Next, abrade by sandblasting, etching, or sanding to impart a light tooth for the paint to bond with. After abrading, wipe away any dust and dry the surface thoroughly, as acrylics will not adhere well to a wet surface.

Some non-porous supports are: glass, hard plastics (i.e., Plexiglas), Mylar, vellum, foam-core, stone, masonry, fiberglass, metal sheeting, and metal or plastic mesh.

flexible and semi-flexible

A traditional flexible support is canvas. Canvas has withstood the test of time and is both relatively economical and durable. Cotton duck or linen canvas is tightly woven and readily accepts paint. It is available in a variety of weights and widths, and is also available primed with a coat of acrylic gesso. There are few things that beat the convenience of pre-primed, pre-stretched canvas supports.

Likewise, paper is a natural, flexible support for acrylics. Good quality acid-free archival papers produced specifically for painting and printmaking are resilient, absorbent, and strong. Depending on the amount of paint that is to be applied, any weight of paper can be used.

Other flexible surfaces would include fabric such as denim or leather. Fabric that will undergo a great deal of elastic movement, such as clothing, will be more tolerant of acrylics if the paints are applied in thin quantities and left to fully cure before being stressed.

I characterize wood as a semi-flexible surface, as even kiln-dried wood will expand and contract with changes in temperature and humidity. It is useful to keep this in mind when painting on this type of surface. To prevent the movement in wood from stretching the paint layers beyond their elastic capacity, one or more additional coats of acrylic primer or medium should be applied. The more acrylic there is on the surface, the more resistant to movement it becomes. In addition, visible knots in wood must be treated with an isolating coat of alkyd or similar product to keep any residual resin from bleeding through the paint film.

rigid

The more sturdy and hard a surface is, the less the chance of damage to the acrylic film. Baring being dropped or smashed, acrylic painted onto a rigid support, such as Masonite, compressed board, metal, or stone will wear extremely well. This is part of what makes acrylics such a good choice for decorative objects and sculpture.

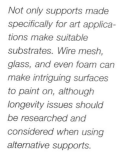

Not only supports made specifically for art applications make suitable substrates. Wire mesh, glass, and even foam can make intriguing surfaces to paint on, although longevity issues should be researched and considered when using alternative supports.

testing the support

Testing a surface for its compatibility with acrylics is not only a good idea, but it is imperative towards ensuring the soundness of the finished product. To test a surface, apply a layer of paint to a small area and allow it sufficient time to cure (two to three days is ideal). Once the paint has dried, rough it up with a sharp tool and apply a strip of adhesive tape to the area. If the paint comes up as you pull off the tape, then the surface is not sufficiently prepared or is not capable of sustaining a bond with the acrylic.

bad choices

Acrylics are bondable to a profusion of surfaces; however, those that are oily, greasy, waxy, or water-sensitive should not be included in that group. Surfaces that have been previously painted with oil media will repel the paint, as will wax. Water-sensitive surfaces, such as rust-prone metals, will be affected by the water content of the paint and will not form a reasonable bond.

priming

Preparing your support for painting ranges from astonishingly easy to enormously complex, depending on various factors. This is one point where it is crucial to know your materials, as the adhesion of the paint to the support is paramount for producing an enduring and stable painting.

Because of their naturally preservative nature, acrylic colors and mediums will penetrate into and bond easily with inert, porous surfaces, effectively sealing them within a matter of minutes. If the intent is to use the color and texture or grain of the support as an integral part of the painting project, applying matte polymer or gel medium will provide a clear, lightly toothy surface. Putting down this isolating layer prevents the paint color from absorbing too readily into the support, a more economical choice than painting directly onto the surface.

Aside from protecting the substrate against deterioration, an acrylic primer, such as gesso, provides a uniform color ground with a small amount of tooth. Because of their high titanium white pigment content, acrylic gessoes are a

A selection of absorbent supports, including archival papers, wood products, and compressed fiber materials.

brilliant white, which provides very good coverage and a bright background for painting. They are also highly adhesive and absorptive enough to accept several paint formats, including oil-based products. Acrylic gesso is largely made up of a whiting agent, in most cases calcium carbonate, which provides the tooth and can also be sanded to create a smooth, even painting plane. Acrylic gesso is pliant and tough enough to be used on both flexible and rigid supports. As the water in the acrylic evaporates during the drying stage, non-rigid supports should be stretched over inflexible frames.

paper

By virtue of its flexibility, acrylic paint is beautifully suited to paper products. Archival art papers can be painted directly with acrylic colors and mediums without fear of adverse results, therefore priming acid-free art papers is purely a matter of personal choice. On the other hand, non-archival papers can be made more permanent by being treated with gesso or an acrylic medium. Use a diluted solution to increase the absorption of the medium into the paper, and apply it to the edges and both sides of the paper for increased effectiveness. It is also advisable to prime or seal handmade

non-archival papers to prevent impurities or volatile elements from migrating into the paint.

When preparing and painting paper, it is imperative that the paper be stretched onto a rigid surface and secured with tape. Water absorption and evaporation will cause buckling and wrinkling unless the paper is of a very heavy weight.

canvas

There is a profusion of canvas and other woven textiles created expressly for painting. They range from light- to heavyweight cotton duck to linen and burlap. All of the artist canvas and linens are appropriate choices for painting; they need only be properly primed then stretched onto a sturdy frame to be ready to paint. (If desired, you can purchase pre-primed canvas to cut down on preparation time.) To properly seal a fabric support, two or more layers of primer should be applied. This can be done with white acrylic gesso, or, as an alternative, a clear, absorbent matte medium. There are priming mediums for sale called transparent grounds or transparent gesso. These mediums dry clear and provide a good amount of tooth.

paper boards

Acid-free illustration boards, watercolor boards, and mat boards are a great choice for acrylic painting, as they will not warp like lower weight papers. These boards can be primed with a layer of gesso or medium or can be painted onto directly.

wood

Some wood surfaces have a beautiful grain that can be augmented by using a simple staining method. Sand and clean the surface to remove any resin or dirt. Moisten the entire surface with water and wipe off any excess. Mix a small amount of transparent color with two parts fluid polymer medium and eight parts water, and then brush on with a large flat brush. Once the color has been absorbed into the grain, allow the wood to dry completely. Brush on a thin layer of fluid matte medium to seal the wood and then paint as desired.

OPPOSITE: *Toronto artist Ben Woolfitt pushes the boundaries of tradition by bringing the character of the acrylic itself into sharp focus by replacing the support with an embedded armature. The transparency and texture of the acrylic becomes sculptural and incandescent.*

RIGHT: *High viscosity interference green paint atop pre-primed canvas boards. Although not as sturdy as professionally built and primed canvas supports, canvases in standard sizes are inexpensive, convenient, and a great jumping off point for your acrylic endeavors.*

This piece is from a series of free-formed pieces of acrylic gels and paint on wire mesh.
I wanted to work with acrylic paint but without canvas, the traditional support used by
artists. I felt that removing the traditional support would allow me to explore the many
properties that acrylics had to offer painting.
Ben Woolfitt

tools

THE CHOICE OF TOOLS is largely an arbitrary one and is affected by both the skill and the adventurousness of each individual painter. There are a few factors to keep in mind when working with acrylics that will help determine which piece of equipment is best suited to the job at hand.

Art supply stores are customarily staffed with artists or people well versed in the attributes and virtues of their products. If you are starting out with acrylics and are unsure of what tools to begin with, you would be well advised to ask their advice. There is a wealth of information there to be tapped.

brushes

As a rule, synthetic brushes fare better with prolonged acrylic use than natural bristle brushes. They are not as absorbent and will not dry out with repeated washings as will hogs bristle or other natural brushes. Other than this general consideration, any shape, size, and style of brush will be compatible with acrylics.

ABOVE: **stencil brush**
The stencil brush is more than a decorator's device. Its flat, dense collection of bristles holds an even concentration of paint and can cover large areas evenly when applied in circular strokes.

RIGHT: **Interlon brushes** *Interlon brushes are made with a resilient synthetic fiber that curves towards the center of the brush to offer optimum strength and control. These brushes stand up well to textured surfaces and are perfect for blending, double loading, layering, and brushwork.*

palette and painting knives

Whether you are looking for something to help scoop paint out of a jar, mix color on the palette, or paint in heavy impasto, there are myriad palette and painting knives available to perform the task at hand. All are acceptable choices, provided they are well cleaned and maintained.

Palette knives are used to mix paints and scrape palettes clean. They can be made from metal, plastic, or wood and will either be completely straight or have an offset handle.

Painting knives are excellent for creating texture, doing impasto work, and applying sweeping areas of flat color. They have a large bend in the handle to keep your hand away from the painting surface, and come in numerous shapes, including diamond, pear, and trowel. The edge of the knife is blunt, so it won't cut the canvas.

taking care

Dried acrylic can be peeled off of plastic palettes and palette knives with ease. To avoid rust forming on non–stainless steel metal knives, give the knives a quick wipe with a rag after rinsing. An accumulation of dried paint can be removed with a kitchen scouring pad.

fan brush *As acrylic paints dry more rapidly than their oil counterparts, there are a few tools that can make color blending less frustrating. Fan brushes come in an assortment of bristle varieties and widths. Their narrow row of fine hairs pulls the topmost layer of paint, creating soft blends and smooth color changes.*

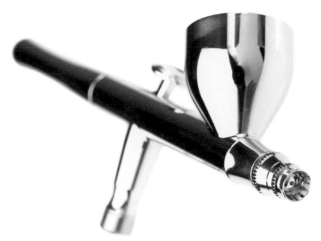

airbrush *Use an airbrush when you want to paint lines, shade from one color to another, or cover large areas with an even coat of paint. Look for a good-quality, external mix unit like the stainless steel airbrush pictured here, which comes complete with a mini hopper to hold the airbrush acrylic paint.*

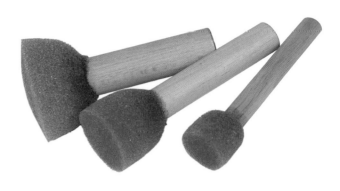

foam daubers *Inexpensive foam daubers can be used for stenciling and printing patterns. The foam can be cut or torn to create interesting shapes and textures with paint.*

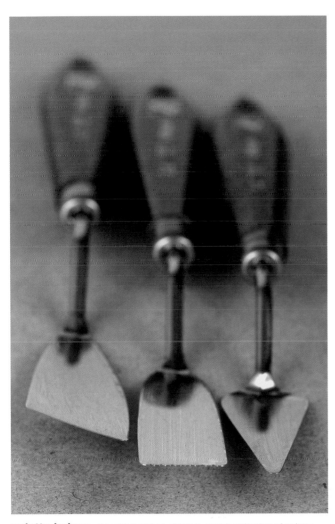

palette knives *As with brushes, there is a wide selection of palette knives available in a variety of shapes and sizes. The metal, trowel-style blades are flexible and set in a wooden handle.*

painting knives *Bendable painting knives are well suited to mixing colors on the palette. Painting with a knife is like spreading butter on bread; it produces a very different result to painting with a brush.*

palettes

In previous decades, the choice of palettes for acrylic paints was limited to those more suited to oil paints or watercolors. As acrylics dry fast and have a tendency to stick quite well to wood, metal, and many plastics, palettes made from these materials are not recommended.

Today, acrylic artists can choose from disposable palettes; tightly lidded palettes with absorbent underpads that keep the paint moist; and glass palettes that can be scraped clean once the paint has dried. Aside from these, there are also non-stick palettes specifically made for acrylic paints. The paint will not adhere permanently to these new palettes, and instead can be lifted and peeled away with ease. These non-stick palettes are particularly useful for creating acrylic sheets and transfers.

specialty tools

In addition to brushes and knives, there are specialty tools available, perfect for creating interesting linework and textures in wet paint.

Because acrylics dry so fast, squeeze only a little paint onto the palette. If you're using an ordinary plastic palette, it's a good idea to have a small spray bottle on hand. While working, spray a fine mist over the paint regularly to keep it moist.

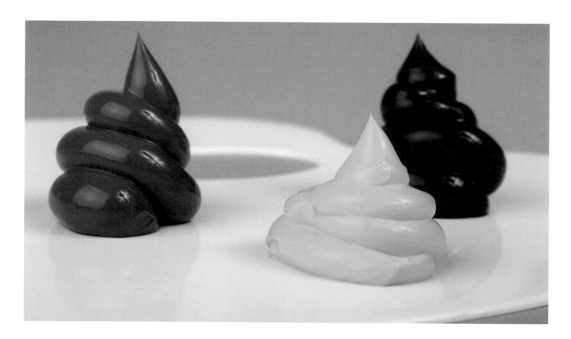

shapers *Shapers are silicone-tipped tools used to spread paint and make controlled marks and textures. They come in a variety of shapes, sizes, and densities.*

brayers *Acrylic brayers can be used for printmaking, as well as to create a variety of slick textures. Brayers, or rollers, are available in acrylic, hard and soft rubber, silicone, and foam.*

graining tools *There are a variety of graining tools available at craft, hardware, and art supply stores. Intended for faux finishing and painting decorative motifs, these tools can provide diverse paint effects in fine art applications.*

charcoal *The dense, velvet blackness of charcoal, vine or pressed, provides drama and optical contrast.*

lithography crayons *Soft or hard, these little black sticks can produce waxy lines that stick well to the acrylic surface.*

wood pencils *Graphite pencils draw exceptionally well on flat, matte acrylic grounds.*

pastels and crayons *Pastels and crayons can be used to apply linear designs over an acrylic ground. Juicy oil pastels and lush, powdery soft pastels create textural visual detail.*

improvisationals

DON'T LET YOUR CREATIVE expression be limited to effects made by the apparatuses found in art supply stores. Acrylics are well suited to improvisation and invention. From the kitchen to the do-it-yourself mega-stores, there are countless tools that can be modified or used directly with acrylics. Shown below and on the opposite page are a fraction of the possible articles that can be used to articulate your acrylic expression.

A pastry decorating tube, coupled with its various tips, is a natural for acrylic paint applications. Icing bags come in several sizes and are lined with plastic, making them easy to clean. The stainless steel or plastic tips are available in a dizzying array of sizes and styles.

For alternative paint tools, check your dishwasher. Graining, sgraffito, and other linear textures are the territory of the old fork, usually one of the first tools to travel from kitchen to studio.

Aluminum foil and cheesecloth can be used as acrylic painting tools, either as texture amplifiers in the background or as stamping tools for creating texture.

Use mesh produce bags to print patterns in wet acrylic paint. Pliant and stretchy, they can be manipulated to form intricate webs of color and texture.

Abrade non-porous substrates, such as glass and metal, to provide a tooth for acrylics to adhere to. Dried acrylic color can be distressed with steel wool to give the appearance of age.

Plastic medicine or chemical droppers are handy tools for mixing, giving artists the ability to draw out and add in small quantities of liquid acrylic paint or ink.

Pastry spatulas and knives make fantastic paint spreaders for large surfaces. They have the flexibility of a palette knife, with the added advantage of greater width and length.

When a palette knife is too narrow for the job, look to the favorite tool of window washers: a squeegee. If desired, the rubber blade of a squeegee can be cut with V-shapes to create a combing tool.

Bamboo skewers play an important role in many art studios. They are handy for scoring into wet paint to create sgraffito, text, or texture.

Acrylics respond beautifully to my thought and working methods, which rely on immediacy, simplicity, precise spontaneity, fluidity, brilliant colors, light, textures, crisp clarity, transparency and translucency. They are an expression of our fast present and are in tune in their own evolution with the perceptive progression we experience in the

ABOUT COLOR

Modern painters can take advantage of centuries of pigment development and research to produce works with a profound vibrancy and superior permanence. The new palette is rife with an intense spectrum of color that grows more profuse with each passing decade.

color in modern acrylics

ACRYLIC PAINT LINES have not always been as extensive as they are today. Advancements in the pigments industry have provided more choices for permanent colors than ever before. Where there was once only a handful of mostly opaque colors, now the palette consists of opaque, semi-opaque, and transparent tones of infinite variety and luster.

Acrylic polymer paints have the clearest binder of any modern paint. Its job is to display the pigment with as little obstruction as possible. The goal of acrylic paint producers is to supply painters with the highest performance materials available. It stands to reason then, that some of the older, less permanent pigments be rejected in favor of stable, dynamic, cutting-edge colors.

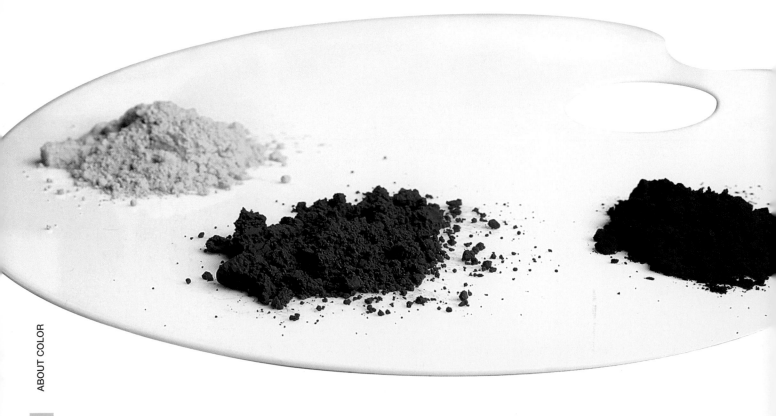

the primary colors

A primary color is one that cannot be produced my mixing two colors together. After centuries of messing around with various red, blue, and yellow hues, it has been determined that the true primaries are magenta, cyan, and yellow, known in the printing industry as the process primaries. Mixing the three colors will produce the cleanest, most accurate secondary and tertiary colors.

The modern pigments that come closest to being true primaries are Phthalocyanine blue green shade, Quinacridone red or magenta, and Arylide yellow medium. Most artist-grade paint lines provide these colors for the purposes of color theory, and for creating clean mixed secondary and intermediary colors. As these are transparent or semi-opaque colors, a small amount of titanium white has been added to the primary version of these colors to give them the right degree of opacity for mixing.

pigments

Inorganic and organic pigments are the two groups used in the production of acrylic paints. These can be broken down further into natural and synthetic sub-categories. The common definition of an organic pigment is that it contains carbon in combination primarily with hydrogen, nitrogen, or oxygen. Inorganic pigments are mineral based and do not contain carbon.

For the purpose of painting, knowledge of the chemical differences of pigment types is not essential knowledge, however it is helpful to be aware of some general attributes of these pigment types.

natural organic pigments

Natural organic pigments are derived from plant or animal matter. One example of this type of pigment is carbon black. Due in part to their insufficient lightfastness, most of the natural organic pigments have largely been replaced by synthetic organic pigments.

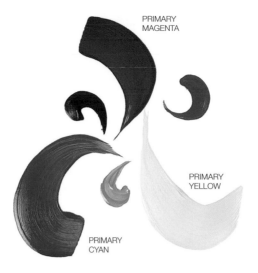

PRIMARY MAGENTA
PRIMARY YELLOW
PRIMARY CYAN

The process primaries: primary magenta, primary cyan, and primary yellow. These are the building blocks of color mixing in graphic and fine arts.

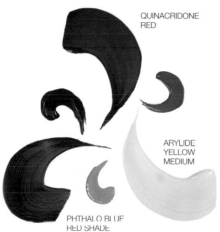

QUINACRIDONE RED
ARYLIDE YELLOW MEDIUM
PHTHALO BLUE RED SHADE

The new primaries: Quinacridone red, Phthalo blue (red shade), and Arylide yellow medium. High performance new pigments with superior brilliance and permanence.

synthetic organic pigments

Synthetic organic pigments make up the bulk of the acrylic color palette. These pigments are at the forefront of modern color technology and are the group into which new colors are making their debut. These are organic pigments that have been produced by means of an industrial chemical process. Although the early pigments of this type, developed in the early nineteenth century, did not exhibit very good lightfastness, the synthetic organic pigments used in modern artist-grade acrylics typically have a very high degree of lightfastness. Phthalocyanines and Quinacridones are brilliant, staining, and extremely transparent. The Pyrolle reds are some of the most permanent pigments out there, and they are also highly staining and very opaque.

QUINACRIDONE RED

TRANSPARENT PYROLLE
RED MEDIUM

ALIZARINE CRIMSON (HUE)

PYROLLE RED MEDIUM

NAPHTHOL RED MEDIUM

CADMIUM RED MEDIUM

These reds range in tone from pinkish to orange-shade, super transparent to exceptionally opaque, garish to smoldering. There is a red to suit every palette, subject, and technique.

natural inorganic pigments

Natural inorganic pigments are often referred to as earth colors, as they are pigments derived from extractions of natural mineral deposits. These are humankind's first colors and some are still very much in use today. Natural iron oxides, umbers, and siennas form the basis of the warm earth tones on many artist palettes. As a rule, pigments in this category are quite opaque, as their molecules are coarse and impenetrable.

synthetic inorganic pigments

Many synthetic inorganic pigments have taken the place of their natural counterparts due to the scarcity and the variation in hue of the natural minerals. The raw chemicals and mineral ores are manufactured through industrial process, thus providing artists with stable, consistent colors with excellent permanence.

the modern palette

In the world of color in modern acrylics, the emphasis is not so much about traditionalism as it is about performance and innovation. There is no compromise when it comes down to choosing between a traditional fugitive pigment and a lightfast synthetic pigment. The most lightfast pigment always wins. If it doesn't pack a punch, it doesn't make the cut.

There are still painters out there looking to find replacement colors to match a fugitive or archaic color from their watercoloring days. Some of the more common colors do have a close modern equivalent, while others will regrettably have to be mixed. The truth of the matter is, beyond attempting to match an existing color (in the case of repair work) or re-create a bygone palette, there is really no practical need for those old pigments. Modern pigments more than fill the palette with clean, vibrant, and varied choices.

Some pigments have been around for millennia, and are still found in even the most current, cutting edge paint range. The ochres (red and yellow iron oxide) and carbon black were among the first pigments ever used and have a continued presence. Alongside these are the raw and burnt sienna and umber

pigments that continue in popularity. It should be noted, however, that many of these mineral colors are now being synthetically produced, to ensure their uniformity and chroma.

The modern artist's palette includes many well-seasoned pigments that sit comfortably side-by-side with the profuse newcomers. Here is a brief look at some of those new pigment groups.

Phthalocyanines In the last several decades, new color families have become a substantial presence in the modern palette. The first of these groups is the synthetic organic Phthalocyanines, a range of blue to green pigments that exhibit brilliant, staining, transparent color. The strength of these pigments lies in the shape and size of the pigment particles; they are miniscule and yet intense with excellent transparency. The Phthalos, as they are commonly referred to, have very high resistance to both UV light and solvents, placing them easily in the top of the group for durability and suitability for outdoor usage.

Quinacridones In the red range, the perfect partners to the Phthalos are the electrifying Quinacridones. These pigments, mostly ranging from light orange red to violet, are equally transparent, with dazzling undertones. Those seeking to replace their Alizarin Crimson will find suitable shades in this color range. As with the Phthalos, the Quinacridone family holds very high lightfastness and permanence ratings. These colors make fabulous glazes and are especially effective as mixing agents.

Naphthols For a middle red range of colors that manifest a warmer undertone, the semi-opaque Naphthol reds must be explored. Naphthols are very staining, non-toxic pigments. To some, they may seem vaguely familiar in tone, as they are also widely used in the production of cosmetics, lipstick in particular.

Pyrolles Among the most recent group additions to the pigment family are the synthetic organic Pyrolles. The Pyrolles run the red gamut and are available in both opaque and

transparent formats. The former makes them a choice replacement for the muddier Cadmiums. Pyrolle reds are similar in hue to Cadmiums, but are considerably more intense, brighter, with a comparable opacity. The transparent versions of the Pyrolles are so new to the acrylic palette that they are as yet mostly undiscovered. These reds are among the most staining, transparent, and permanent pigments. The Pyrolle colors represent the cutting edge of pigment research, giving us a tantalizing taste of the many great colors yet to come.

Bismuths Another new group on the palette is the Bismuth yellows. Extremely opaque, these yellows range from light to deep and offer a bright alternative to the Cadmium yellows. They have a high chroma and very good covering power. These are synthetic organics with a high degree of lightfastness and weather resistance. Although they are relatively expensive, these yellows are strong enough to pack a punch even when applied in small quantities.

Isoindolinone Yellow Isoindolinone Yellow, the recommend replacement for Indian Yellow, is a brilliant, reddish yellow color with excellent lightfastness. This transparent color has the golden intensity of a ripe mango and is an indispensable

glazing tone. In some lines this yellow is labeled as Indian Yellow, though the thing to look for is the pigment identification number, PY110.

Nickel Azo Yellow An intense, greenish yellow that is very transparent and extremely permanent is Nickel Azo Yellow. This is a color that is often overlooked, as its mass tone appears rather lackluster and muddy. In contrast, the undertone of this particular yellow is an almost fluorescent sulphur yellow. There is no other yellow that can match its intensity and sharp color. I have found this hue, in a wash, to be a gorgeous underpaint for a glaze. When it is blended with Indian Yellow, the artist can create intense, transparent colors that span the full yellow spectrum without sacrificing lightfastness.

Iron Oxides The autumnal shades of the synthetically produced transparent iron oxides are indispensable not only for glazing, but also for any aspect of painting with transparency. Ranging from a warm yellow to a gold orange, these are affordable, highly resistant colors and each show off a bright undertone with the luminosity of amber and cognac. In addition to this, they are exceedingly stable, permanent colors. Applying a light glaze of any of the transparent iron oxides will give an oil painting an antiqued appearance.

ARYLIDE YELLOW MEDIUM

BISMUTH YELLOW MEDIUM

CADMIUM YELLOW MEDIUM

At first glance, the various yellows appear deceptively similar, but on closer inspection their individuality becomes apparent. One way to further explore the subtle nuance of a yellow (or any tone for that matter) is to mix it with white.

mass tone and undertone

The mass tone of a color is the surface appearance of a color in a dense quantity. The undertone becomes visible when a color is thinned out in a glaze or wash. This duality is much more apparent in transparent colors, as due to their translucent nature they appear to be quite dark in mass tone while exhibiting an extremely vibrant undertone.

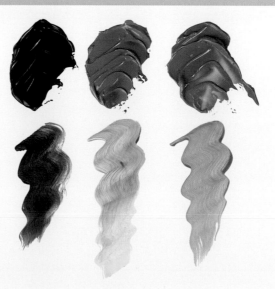

I chose three transparent colors to show the duality of color exhibited in their mass tone (top) and undertone (bottom). Colors from left to right: Transparent Gold (red) Oxide, Nickel Azo Yellow, and Indian Yellow.

questions of color

What are pigments?

Pigments are finely ground powders derived or manufactured from a variety of sources. These powders provide color and also impart the paint with other characteristics, such as opacity, light-stability, and durability. They are natural or synthetic, inorganic or organic particles that are dispersed into a variety of chemicals and then added to the acrylic polymer resin to make acrylic paint. The color index name is one of the primary systems used in pigment identification.

How are pigments different from dyes?

Dyes are colors which are soluble in the liquid they are introduced to and will stain freely. Pigments are insoluble and cannot form a bond with or stain a surface unless they have been united with a binder. Dyes are not considered to be permanent, whereas pigments range from fugitive to extremely permanent.

What do color index names refer to?

The index names refer to a specific pigment. However, there are innumerable grades and shades of pigment within each color index name. The color index name identifies the color as a pigment (P) or dye (D), by it's general hue (B=blue) and assigned number. For example, the color index name for Dioxazine Violet is PV23 (pigment violet 23). Blended colors will be marked with each of the pigments present in the blend. For example, the color blend for Alizarin Crimson (Hue) is PR 170, PR 101, PV 23 (Naphthol Red Medium, Transparent Red Iron Oxide, and Dioxazine Violet).

How permanent are artist quality colors?

Each color in most artist quality lines has a lightfastness rating of excellent to very good in accordance to ASTM standards. Colors exhibiting this caliber of lightfastness are considered to be permanent.

What does lightfast mean?

A pigment is considered to be lightfast, or light stable, if it resists fading over extended exposure to ultraviolet light. A pigment that can not stand up to direct exposure to UV rays without fading is considered to be fugitive.

How do I know if a color is transparent or opaque?

The term used to describe a color's transparency or opacity is relative coverage. On the label and brochure information of most acrylic paint manufacturers each color is tagged with a letter signifying its relative coverage: (T) Transparent, (SO) Semi-opaque, and (O) opaque. The primary factor that determines a pigment's transparency is the size of the pigment molecule. The smaller the molecule, the more transparent the color. Some pigment molecules, such as Phthalocyanines, are also translucent. Inorganic colors are largely opaque due to the size and opacity of the molecule.

Are transparent colors weaker than opaque colors?

Actually, both can be very strong colors, although transparent colors are generally more staining than opaque colors due to their much smaller particle size. Colors with small particle size pigment can be loaded into the acrylic in higher volumes, therefore exhibiting a higher chroma. For example, Dioxazine Violet and the transparent Pyrolle reds are vibrant colors that can produce intense and saturated tones even when used in minute amounts.

Can I make opaque colors more transparent?

In order to increase the transparency of any color, it needs to be extended with a clear medium, such as a polymer or gel medium.

The farther apart the pigment particles are, the more transparent the color becomes.

Why do some colors appear matte while others are very glossy?
The surface appearance of any color in an artist quality line is determined by the characteristics of each individual pigment. In general, inorganic pigments will have a more matte appearance than organic pigments. This is due to the particle size and opacity of the particle. Large, coarse pigment particles scatter the visible light, making the color appear more matte. Synthetic organic pigments with a very fine particle size, such as Phthalos and Quinacridones, appear very glossy, while more coarsely ground pigments, such as umber and ultramarine blue, have a much more matte finish.

What is the difference between C.P. Cadmium and a Cadmium medium (hue)?
C.P. Cadmiums are deemed "clinically pure" and of the finest quality, and are priced accordingly. Cadmium "hues" are derived from one or more different pigments to look like Cadmiums in every aspect but price.

What is the purpose of having "hues" in the acrylic paint lines?
The "hues" in acrylic lines have been added to the color line-up to take the place of pigments that are either unavailable, incompatible with water-based emulsions, or are price prohibitive. Some pigments that are too fugitive to be included in an artist-grade paint line are replaced by a permanent pigment or blend. In other instances the reasons are health related. In the case of Naples Yellow, one of the first synthetics, the Lead-antimonate pigment has excellent permanence, however it is highly toxic. A mixed Naples Yellow Hue now replaces this obsolete color.

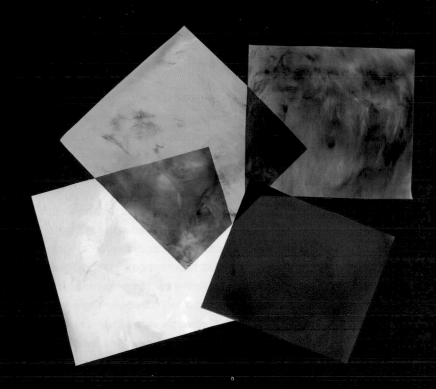

Why are pure Cadmiums not generally offered in liquid format acrylics?
As Cadmiums are considered to be toxic when inhaled, they have been widely left out of liquid format acrylic lines to prevent them being applied with spraying tools, thus reducing the risk of their being inhaled.

What are the characteristics of Bismuth yellows and Pyrolle reds?
These two color groups are among the latest in newly developed inorganic and super organic pigments. They have been included to provide artists with an alternative to the mildly toxic Cadmiums. These colors are as opaque as Cadmiums, have a very similar tonal hue, offer equal to superior lightfastness, and are cleaner mixing colors.

Why are certain colors more expensive?
The most costly component of any paint is the pigment. Each color is made up of one or more pigments, coming from a staggering variety of sources. Each of those pigments in turn has gone through a variety of manufacturing processes in order to become a compatible component of the paint.

Squares of transparent color and self-leveling gel: Phthalo turquoise, Phthalo blue green shade, transparent Pyrolle red medium, and Indian Yellow.

ABOUT COLOR

53

iridescent colors

They are shiny, opulent, and very rich looking. Acrylic iridescent colors, usually available in both high viscosity and liquid formats, are the stuff of pirates' dreams: gold, silver, bronze, and copper hues that paint on with the ease of warm butter and have the patina of metal. The iridescent acrylic palette is a gorgeous enhancement to acrylic lines.

Pigments such as these can be used to simulate metal in a painting, although they can also provide depth to a translucent glaze or a reflective backdrop for layers of transparent color. Adding a small amount of iridescent color to another pigment can add radiance to the color without making it appear brassy.

Iridescent colors make an easy stand-in for metal leaf or metallic powders. With the addition of an assortment of mediums, they can be made to mimic various surfaces.

Iridescent colors are semi-opaque to transparent, depending on the abundance of pigment in the acrylic, which varies from brand to brand. In premium brands, the level of pigment can be very high, creating paint with superior opacity and covering power.

working with metallics

Metallic colors in acrylic paint lines have the same handling properties as the other colors in their respective families. For example, a high viscosity iridescent or interference color is generally as thick and creamy as a non-metallic high viscosity color. Interference and iridescent colors can be mixed in any quantity with other acrylic colors, though they are most visible when paired with transparent pigments. And, interference and iridescent acrylic colors can be sprayed through an airbrush, if the most finely ground varieties are used.

Metallic iridescent pigments, made with colored mica particles, are lustrous and opaque. Both liquid and high viscosity formats are richly pigmented.

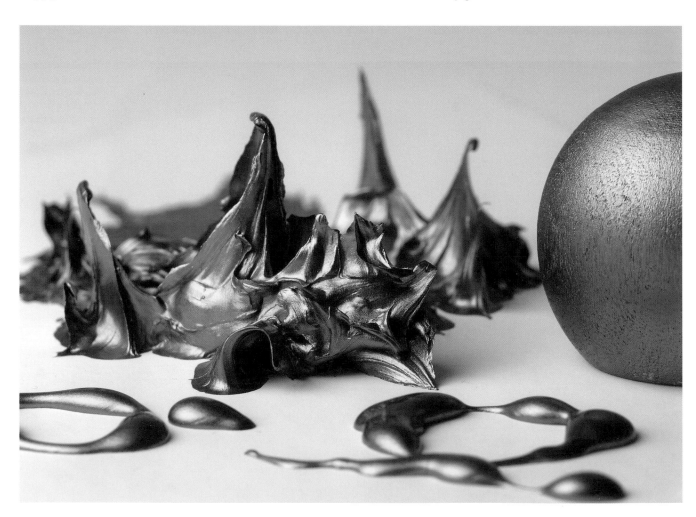

unique and unusual pigments

ASIDE FROM PRODUCING the wildly popular metallics, acrylic paint manufacturers are offering artists colors that are a bit more out of the ordinary.

graphite gray

One such unusual pigment is Graphite Gray. Graphite gray paint, made from inert elemental carbon particles, is quite an understated yet exceptionally sophisticated color. Graphite has low tinctorial strength and low color intensity; however, it is very soft and thus can be burnished to a delicate sheen. Imagine painting with a graphite pencil, and you can visualize the depth of this gray paint. In addition to taking part in painted artwork, it is also perfectly in tune for accenting interior design aspects in the home.

phosphorescent and fluorescent colors

Phosphorescent or glow-in-the-dark paints gather light from exterior sources, then store and reflect it back at a lower intensity. The

ABOVE: *Phosphorescent high viscosity paint.*

LEFT: *Graphite gray acrylic paint utilizes a fine dark grade of graphite as the pigment. It has a subtle sheen and a neutral tone.*

higher the UV concentration, the brighter the afterglow will be. The pigment is rather coarse, as over-grinding will break down the particles and cancel the glow, and needs to be used in large quantities to be very effective. For the strongest afterglow, it is best not to add any other pigment to the paint and to use a white or light undercoat. Phosphorescent color is fairly fugitive, but its particular ability to give off light necessitates its inclusion in the acrylic medium. In this format, there are unlimited possibilities for glow-in-the-dark application.

Fluorescent colors also have a distinctive gleam that gives them wide appeal for banners and advertisements. They do not store light as the phosphorescent pigments do, but have an electrifying glow in a rainbow of colors. When the light source is removed, the glow disappears as well. These colors are found only in economy lines, as they are inexpensive to produce, but as yet have only a lightfastness rating of fair. These colors will glow under black light and are most potent when painted onto a white ground.

micaceous iron oxide

Another unique color is Micaceous Iron Oxide. This is paint colored with micaceous iron oxide, also known as specular or lamellar hematite, which is gray with an understated metallic sheen and is spectacularly durable. In fact, this is the very stuff that protects the Eiffel Tower from corrosion and weather damage.

This pigment is unique, in that it is literally crushed rock, and hence has a fine, gritty texture. The coarse grind gives the paint a grainy surface that catches and locks in loose material. As such, it can be painted on to create a wonderful dark ground for pastel or other dry media work.

OPPOSITE: *Joanne Handley utilizes micaceous iron oxide and metallic pigments to impart a lush and complex character to her paintings, with textures that range from a highly burnished finish akin to that of metal substrates, to the roughened mineral graininess of quarry rock.*

RIGHT: *Micaceous iron oxide acrylic paint exhibits a fine granular texture, deep gray tone, and shimmering reflective surface. Painted on as a ground for soft pastels, it is a rich alternative to traditional pastel papers.*

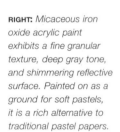

Modern acrylics are a remarkable departure from the odorous, student-quality acrylics used in school art rooms in the 60's and 70's. Today, they can be deliciously buttery with excellent film integrity and coverage. They often exhibit attributes once only obtainable in oils and yet have no smell and wash up with ease. Modern acrylics represent the vanguard of new paint technology, providing the contemporary painter with a range of innovative and high-tech applications without eluding them the high pigment load and rich character they so dearly seek.

Joanne Handley

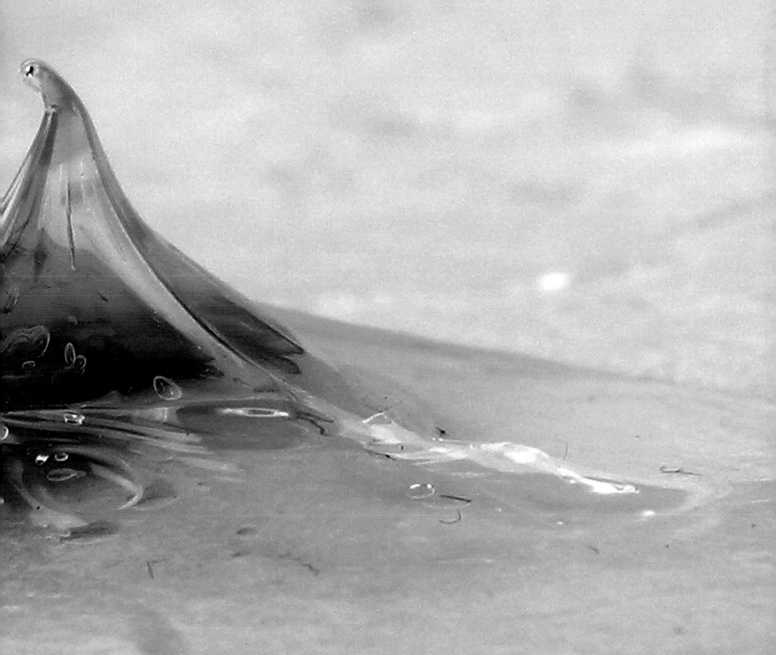

ACRYLIC
MEDIUMS

Manufactured as an integral part of the acrylic system, acrylic mediums form the backbone of acrylic painting technique and provide the artist with the vehicle needed to achieve an endless variety of effects.

unraveling the mystery of mediums

WHAT SEEMS TO BAFFLE the acrylic novice is neither the stunning variety of color choices, nor tackling a subject matter, but rather how to penetrate the mystique of acrylic medium. "What is all that stuff anyway?" you ask. You look near the rows of tubes and pots of gorgeous colors, and there they are. They're all the same color, all seem to possess very similar characteristics, and there is this haze of generality in each descriptive label.

"Hmmm . . . Which one to buy? And why? Are any of them even necessary?" You make a mad grab and try to look like you know what you're doing. Once you get the pot of whitish, thickish goop home you look at it skeptically, prod it with a palette knife, and stick it up on the shelf with the good intention of finding something very interesting to do with it some day, when you're feeling a bit more adventurous.

Gloss gel mixed with a small amount of iridescent gold paint and transparent red oxide has the look of burnt sugar caramel crystal.

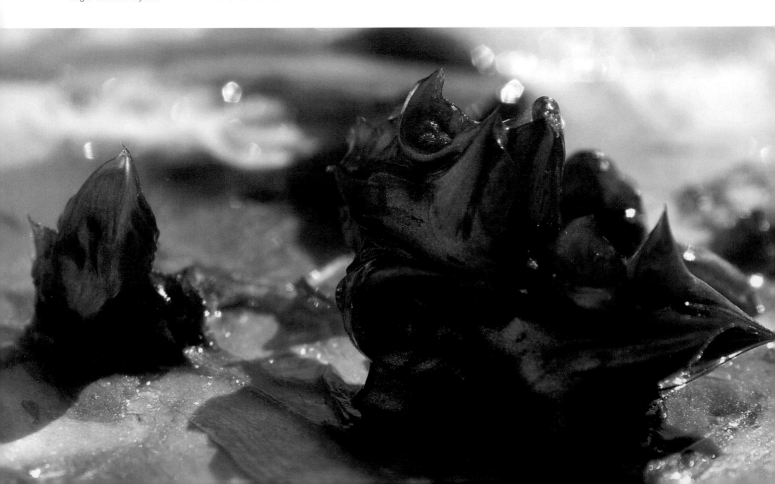

A sea of gloss gel medium ready for capping. Gloss gel medium is the most basic and versatile of all acrylic mediums. It represents a substantial proportion of acrylic mediums sold.

It's a scenario being played out in studios around the world. Neglected jars of glop, silently gathering dust. But it doesn't have to be that way.

Along with developments in color and chemistry comes a plethora of acrylic mediums, which, in accompaniment to the colors, do a great deal to expand the range of acrylic expression. These are the quiet heroes of the painting world, modestly blending into the background and surfaces of each masterpiece while color, composition, and light intrigue and dazzle, shamelessly basking in the "oohs" and "ahhs" of admiration. But it is the modest yet versatile acrylic mediums that extend and augment the paint surface, showcase the virtuoso, and provide those innumerable visual and tactile effects. Acrylic mediums are not merely garnishment; they are essential partners to the colors.

Acrylic mediums and additives fall into five basic categories: gel mediums, liquid mediums, specialty mediums, grounds, and finishing mediums. Within each category there exists an assortment of highly diverse mediums. Each has its own unique qualities and capabilities that make it an indispensable part of any artist-quality acrylic paint line.

As acrylic manufacturers are continuously coming out with new and varied mediums, it would be impossible to explore them all. The mediums mentioned in this book are by no means the full extent of the products available in the marketplace today. Instead, the mediums explored here are just a sampling of the ever-expanding assortment of mediums currently available.

why add medium?

The addition of mediums to acrylic paints gives the painter control over viscosity, color saturation, and luster. Adding acrylic polymer mediums to acrylic colors will also increase the open time of the paint.

THE CONFUSION surrounding the diverse world of the acrylic mediums and additives is largely because they appear more similar to each other than distinct. Each medium is part of the acrylic family and they are all produced with the same basic ingredients; hence, the oftentimes repetitive label information. With the exception of acrylic retarders and flow-release agents, the mediums share a similar base with the acrylic colors, minus the pigment. What discerns one from the other is primarily how it feels and how it dries.

In order to shed some light on the subject of their viscosity and tactile characteristics, I have likened a few of the more popular mediums to something everyone has a visceral understanding of. Acrylics are so often referred to as being delicious, juicy, creamy, buttery, crisp, luscious—all terms that we use to describe foodstuffs. I have approached mediums through the kitchen door to tempt and delight, while doing a little educating on the side. Get sticky in it. Think of them as food. Bon appetit!

gel mediums *These mediums have a creamy, buttery viscosity that can be easily manipulated with the softest of brushes. It will hold the imprint of each brush and knife stroke.*

nepheline gels *Extra coarse nepheline gels exhibit a rough, irregular texture. The nepheline particles are bound together with highly flexible, clear gloss gel.*

self-leveling gels *This gel is thick and viscous, similar in texture to honey.*

modeling paste *This modeling paste has the look of a stiff whipping cream. It's sharp peak-holding capability and crisp whiteness provides a semi-flexible ground for acrylics.*

self-leveling gels *Oozing out in soft folds, self-leveling gel will even into a level pool of medium with a very glossy, smooth finish.*

self-leveling gels *This wrap was formed with self-leveling gel medium edged with green paint and lightly speckled with mica particle paint.*

modeling paste *Due to its high talc content, modeling paste has greater density and weight than standard gel mediums. A large titanium white pigment adds to the bulk of the paste, which dries very white, matte, and absorbent.*

dry gel mediums
Here, squeezed out of a pastry decorator, dry gel medium has the appearance of glass noodles. Use dried gel medium to add string-like textures to paintings or sculpture.

liquid polymer mediums *These mediums are pourable, with a consistency similar to that of a sugar glaze. Thick or water-thin, acrylic polymer mediums are also powerful adhesives. Flecks of decorative silver leaf have been sprinkled on the glaze for an artistic finish.*

liquid glazing mediums *Liquid glazing mediums are almost water-thin and hold no visible texture. Low viscosity polymer mediums have the identical appearance and texture.*

acrylic gesso *Gesso is now available in more colors than the traditional white. For creating alternative colored grounds, it is also available in black, burnt umber, and canvas tones.*

water

THE FIRST MEDIUM in the acrylic system is water. It is one of the primary components of the paint and can be mixed into acrylics in any quantity. Water is used for a variety of techniques, including the important task of cleaning painting tools. It can be used to create thin washes, in wet-in-wet technique, or to reduce the viscosity of the paint or medium. As the bulk of pigments used in artist-grade acrylics have a very small particle size, there will not be any noticeable grittiness when the colors are diluted in a wash.

Water can also be misted onto the palette to keep paints wet during use. A mister can also be used to hydrate paint while blending.

Introducing water to partially dried paint can produce varied results. Experiment with this technique before applying it to your artwork.

The acrylic molecules will spread farther apart as more water is added. This can significantly compromise the elasticity and binding properties of the paint film. However, this is not an issue if a thin water wash is applied below subsequent paint layers. The top layers will seal the surface and give it more tensile strength.

deionized water

The water used in the production of acrylics is customarily deionized water. The vast majority

The ubiquitous, yet least talked about acrylic medium is water. As it is one of their main constituents, acrylic colors and mediums can be mixed in any proportion with water.

Magenta light liquid on tap.

of dissolved solids in modern water supplies are ions such as calcium, sodium, and so forth. The deionization process removes ions from the water, reducing it to a non-mineral state. This high purity water is the ideal water to use with painting; however, its limited commercial availability makes it impractical.

distilled water

Distilled water is water that has been purified by passing through an evaporation-condensation cycle. This type of water contains small quantities of dissolved solids. Distilled water is the preferred choice of watercolor painters,

as the amount of pigment used is relatively small and, although the effect is very minimal, the chlorine in tap water can cause bleaching.

tap water

Tap water varies from town to town, and, for the most part, it is safe to use with acrylics. Still, water used for general consumption does contain minerals and bleaching agents that could have a detrimental affect on the pigments. This is a very low consideration however, as the pigment to water mineral ratio is quite drastic. When longevity is an important factor in the creation of a painting, use distilled water.

Thin color wash brushed into texture and left to pool.

gel mediums

LET'S FACE IT, acrylic gel mediums are great. You can do so much with them . . . glob them on thick, sculpt them, embed stuff into them, fill spaces with them, coat things, seal things; they are the best all-around, do-it-all mediums. Essentially, gel mediums are high viscosity paints minus the pigments. They behave in the same way in terms of their drying time, manipulation, and elasticity. In fact, the only visible difference between a gel and a high viscosity paint is the gel's complete lack of color.

Milky white in its wet form, gel medium will dry to a clear film, leaving the chroma of any added pigment unchanged. This is the medium to use when high relief and crisp textural detail is desired. Artist quality gel mediums will hold detailed and flexible peaks several inches high, yet they can also retain the minute impression of something as subtle as a fingerprint.

Gel mediums are primarily used to augment the viscosity and texture-maintaining properties of any format of acrylic paint, from high viscosity colors to acrylic inks. Silky and creamy to manipulate, they are easy to apply with brushes, fingers, paint knives, or any number of tools.

Gel mediums are available in gloss, semi-gloss, and matte formats, allowing the painter to either add or decrease luster and tooth. Matte and semi-gloss gels contain a matting agent, similar in configuration to crystal. The matting agent works towards breaking up the surface and refracting light. The matting agent also adds a light tooth, creating a velvety surface ideal for sketching with charcoal, pastels, or any other drawing media.

Another unique quality of this type of medium is its ability to encase an object and effectively seal it in a capsule of acrylic. Like an insect trapped in amber, inert materials and objects pushed or mixed into a blob of gel will be moderately protected from water, air, and the ravages of time once the acrylic is completely dry. This is a great way to preserve vulnerable materials and incorporate them into collage.

There are no limits to the types of utensils that can be used to manipulate gel mediums; anything from brushes to fingertips will do the trick. Be spontaneous! Look around your home and in art supply, craft, and hardware stores to come up with unique paint applicators.

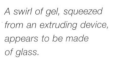

A swirl of gel, squeezed from an extruding device, appears to be made of glass.

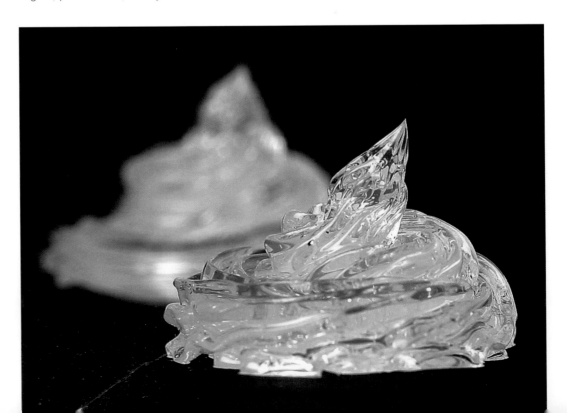

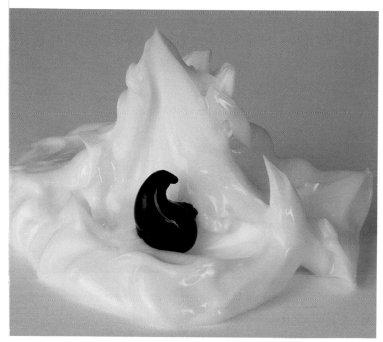

1 Strong colors, such as this Phthalo turquoise, can be used in very small quantities to create vibrant glazes. This glaze is made up of one part color and twelve parts gloss gel medium.

2 Mix the gel and color thoroughly with a palette knife or brush.

3 The wet glaze will appear dull and somewhat pale. The water in both the paint and gel appears white in the wet acrylic binder.

4 Once the water evaporates from the glaze, the gel clarifies. The glossy, transparent glaze becomes luminous and vibrant. A glaze of this thickness will take several hours to clarify.

specialty mediums

IN ADDITION to liquid and gel mediums, artists today can take advantage of an assortment of specialty mediums and additives to bring distinction and character to their work.

texture gels

The majority of acrylic manufacturers provide painters with one or more texture gels. These are gels that have inert particulate matter added to them. These particles include marble dust, pumice, ceramic beads, fibers, and various mineral compounds. Depending on the content, they range from transparent and translucent to opaque. The elasticity and flexibility of the gel itself keeps the particles bound in the mixture, though higher concentrations of inert particles can produce a less supple paint film. When tinting these types of mediums with color, attention should be paid to the transparency of not only the medium, but of the color as well. A high concentration of opaque color is needed to tint the more opaque gels, while translucent and transparent texture gels can be successfully tinted with a modest amount of any color type.

The texture mediums showcased here are nepheline coarse and extra-coarse gels. These gels contain nepheline syenite, a light to medium-gray, igneous rock that consists mainly of nepheline and alkali feldspars. The particles provide a granular texture within the clear gel. This is a great surface for rough sketching with drawing materials, scrumbling technique, and mixed media. The fine rock grains also add toughness to the acrylic film while remaining flexible enough to be used on pliable substrates. The nepheline syenite's granules range from clear to black or brown, creating a semi-transparent medium with a distinctly granite-like appearance.

Although the nepheline gels contain colored granules, they still maintain a great degree of transparency. They can be tinted with liquid, ink, or airbrush acrylics in any proportion, without imparting a gray cast to the mix, as with more opaque pumice gels.

Extra coarse nepheline gel contains nepheline granules of larger sizes for creating textures that are more irregular. As the particles are larger, the clear gel binding them is more apparent.

LEFT: *Adding one part color to eight parts nepheline gel will create a richly tinted granular paint.*

BELOW: *A small amount of cobalt teal mixed with nepheline coarse gel.*

self-leveling gels

Self-leveling gels are those which have a thick, honey-like feel. They are heavy, gooey, and sticky. Unlike regular gels, this material will level out completely into a thick, even pool. Deep, viscous color glazes can be achieved with this medium.

There is one important thing to keep in mind when working with a self-leveling gel. Think of how honey behaves when you stir it up. The air bubbles created by the agitation get trapped in the thick honey and take considerable time to escape. The same is true of self-leveling gel. The pressure of the gel leveling out forces the air bubbles down, and as the medium dries, many of those bubbles will not have enough time to work their way out of the paint. The best way to mix color with this type of gel is in a resealable container. Add the color to the gel, mix well, and seal. Leave the gel in the container overnight. During that time the bubbles will have escaped and the gel will be ready for application.

I have found that this type of gel will remain relatively free of bubbles if applied with a palette knife, or any flat spreading tool, rather than a brush. The brush bristles trap air that can be pushed into the gel. As with all other gels, this medium will dry clear and extremely flexible. It is a fabulous adhesive for embedding heavier collage elements into a painting.

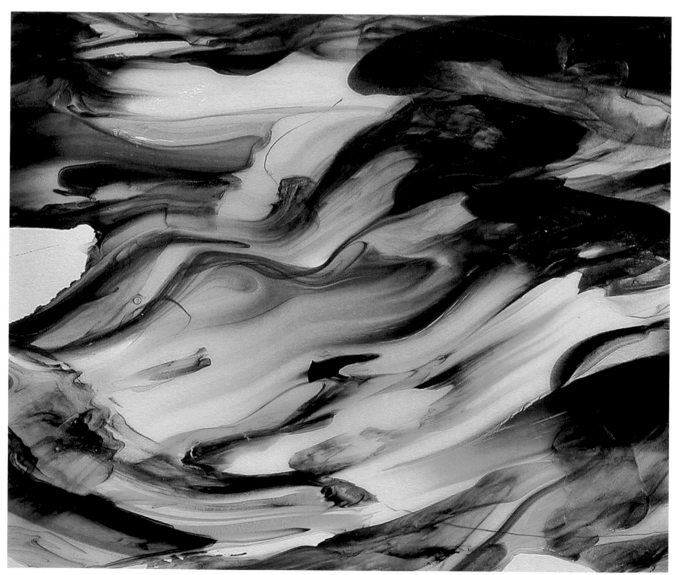

Phthalo blues and greens swirled through a pool of self-leveling gel.

1 Liquid colors are packaged in formats that facilitate controlled tinting. Color can be added drop by drop to tint a glaze, mix a tone, or produce swirling patterns in gel.

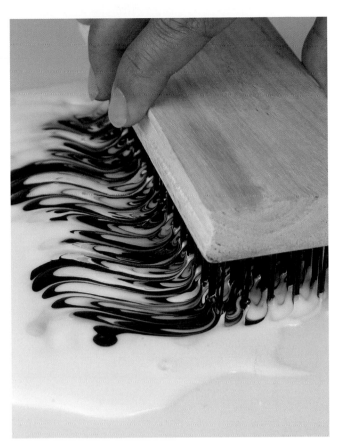

2 To create a marbling effect, a metal bristled brush tool was pulled through self-leveling gel and two purple tones.

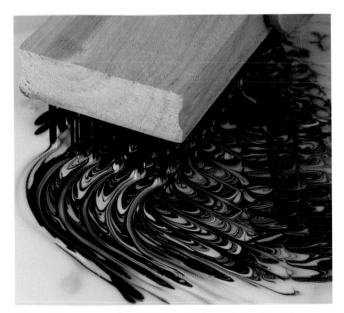

3 The brush was passed through the gel in alternating directions to mimic the appearance of paper marbling.

4 A close-up of the finished effect. In addition to a brush, other tools found in hardware and craft stores can be used to add variety to the repertoire of effects that can be created with acrylic mediums.

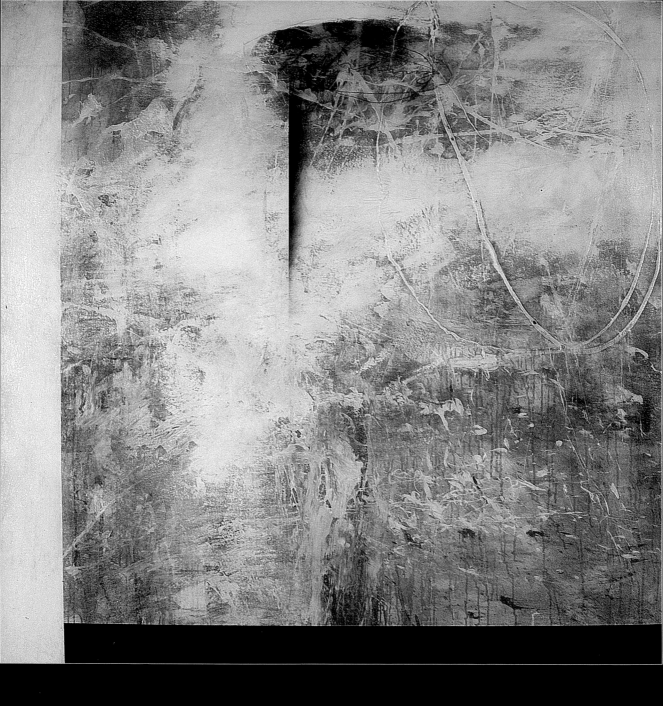

During my formative years as a student of art, the "new" acrylic mediums were generally quite expensive, and although they were readily available, they were in their infancy and limited in their range of colors. As my career developed, so did the acceptance and increased usage of acrylics vs. traditional oils. The negative perception of early acrylics was quickly dispelled and today it is considered a viable and valuable medium in the eyes of collectors and galleries.

retarders and flow release additives

Acrylic retarding and flow release mediums decrease surface tension and drastically slow down the drying process. These types of mediums are at their most effective when used in airbrush or ink pen applications.

Acrylic retarder is an agent that can be added to acrylic colors and mediums to keep the paint wet and workable a little longer. Adding a small percentage of retarder to the paint facilitates detailed glazing techniques and soft blends. Retarder can also be brushed onto the ground or support before paint application. This coating becomes an absorbent ground that will keep the color wet long enough to produce smooth color blends.

Flow release is the potent, Herculean version of the acrylic retarder. This type of additive is useful in the case where the paint mass is very small and the support is highly absorbent. For example, adding flow release in a 25% concentration to acrylic ink will keep the ink wet in an open container for the better part of a day. This is of benefit for calligraphy and other pen and ink applications. Mixing airbrush acrylic colors with flow release will keep the paint usable for a longer period of time. It will also reduce clogging at tip of the airbrush. In both these cases, the volume of paint being applied is significantly low—either a thin line or fine spray—thus the majority of it will absorb into the support or ground. Paint thinned with flow release should not be applied in heavy quantities. If it is brushed on in any volume, there will be too much paint resting on the surface of the support. The paint will remain tacky for a prolonged period of time and will not form a cohesive paint film.

Many acrylic painting accidents involve the overzealous use of retarding additives. These are the one family of things that can dump your painting into the bin of no return. Novices to the field of acrylic painting sometimes make the assumption that if they add enough retarder the paint will behave more like an oil paint. This is not so. The product of immoderate use will be a gluey, sticky mess that may never dry.

The main component of an acrylic retarder is propylene glycol. This provides freeze/thaw stability for the wet paint, but also serves as a humectant. Simply put, it keeps the water trapped in the acrylic film. The more glycol present in the wet paint, the longer it will take to dry. There is a certain balance that must be maintained in the proportion of glycol to the other solvents and minerals in the paint. If the glycol content is too high, the paint will not dry properly. That is not to say that it will remain workable. Some water and other volatile solvents will continue to evaporate regardless of the glycol quantity. This results in a paint film that is too gummy to be worked with painting tools and that will lift off the support. In the case of excessive retarder abuse, the paint film will stay tacky and unresolved indefinitely. Adding more paint layers over this partially wet film will be unsuccessful.

In short, acrylic retarding agents are useful for several applications if used in the correct proportion. Taking the time to read the product label and following any instructions in the corresponding brochures will ensure the best results.

OPPOSITE: *In this painting, artist Drew Harris drips generous quantities of self-leveling gel in stringy arcs to create underlying texture, part of the language of his subtly dynamic and evocative paintings.*

BELOW: *Acrylic retarder and flow release agents are translucent and can become slightly gray or yellowish as they age and are exposed to UV light. This light discoloration in no way affects the hue of the paint, as once it has done its job, it completely evaporates from the paint film.*

grounds

THE PURPOSE of an acrylic ground is to protect and seal the support plus provide the paint with something to bond to. Absorbent supports like paper, wood, and canvas will readily soak up the paint. Applying a gesso or other base coat not only seals the material but allows the paint to flow more freely over the surface instead of getting caught in the grain. Priming the paint support is economical as well as vital to the longevity of a piece.

Even thoroughly dried acrylic can sometimes fall prey to water, chemical, or mildew damage. One way to guard against this is to seal a porous support in order to inhibit the absorption of any agents that could have an adverse affect on the paint film.

Priming wood and wood products is of particular importance for several reasons.

- Change in temperature causes wood to shrink, expand, and warp, which can stretch the paint film beyond its tolerance.
- Water absorption into the wood either from exterior sources or from the paint itself will cause the wood to expand while wet and contract as the paint dries. This could cause the paint to dry unevenly, which can trigger cracking or cratering.
- Any sap still present in the wood can inhibit proper curing in the paint, and can stain light colors.
- Large knots in wood should always be sealed with a proper wood sealer before being primed with an acrylic product.

IN THE CASE OF PAPER, fabrics like canvas, and prepared wood, priming becomes a choice rather than a prerequisite to painting. The acrylic paint itself will effectively seal porous surfaces, so there is no need to prime it if the desired effect is one that incorporates the character of the material.

When applying the first layer of paint, medium, or gesso to paper it is imperative that the paper be stretched onto a rigid support, as the water in the acrylic will cause the paper to buckle and warp. Very heavy-weight art papers (300 lbs and up) are not as susceptible and may not require stretching.

a note on MDF

Medium density fiberboard, or MDF, is a wood by-product and an ideal painting support. As it is inert, very dense, and completely without grain, MDF absorbs waterbased products evenly and slowly. It has a very smooth surface and very little primer is required to seal it. It makes a very effective foundation for building objects that are to be painted. The one thing to be vigilant about is ensuring that every part of the MDF is well sealed if it is to be kept anywhere near water. Once water has penetrated the core of the MDF it will cause the board to expand and the overlaid paint will lift and bubble.

mixed media

One of the most crucial scenarios in which to be mindful of proper priming practice is in mixed media applications. Once dried, acrylics on their own will not have a corrosive effect on any support, but that is not true of all art media. Solvent- and oil-based materials will readily attack many types of surfaces. To protect against deterioration, discoloration, and other destructive concerns, properly seal all supports when doing mixed media work.

ABOVE LEFT: *A stencil pattern applied directly to canvas primed with matte medium.*

ABOVE RIGHT: *Primed canvas accepts a loose application of color without bleeding or beading.*

LEFT: *Preparing fiberboard surfaces with one or two layers of gesso will reduce paint absorption. Swelling caused by moisture from thick paint applications can be prevented by sealing the front surface, sides, and back of the board*

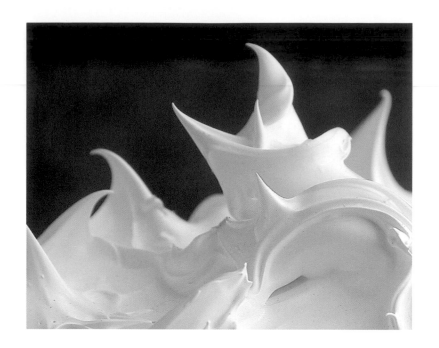

modeling paste

Modeling or molding pastes provide opaque textured grounds that can be modified in various ways. They have a putty-like consistency that ranges from light and fluffy to dense and heavy.

This type of medium is most commonly a combination of thick gel, titanium white pigment, and calcium carbonate. There are some modeling pastes that have less or no titanium white pigment added, and some that contain bulking agents other than calcium carbonate.

Generally, modeling pastes dry white. The calcium carbonate serves to increase the bulk of the gel and provides a tough absorbent ground that can be sanded or carved into when dry. The high acrylic content helps to maintain a good degree of flexibility in the

ABOVE: *Modeling paste has the ability to be formed into dramatic peaks.*

RIGHT: *Modeling paste with embedded objects: jute, bone, and metal.*

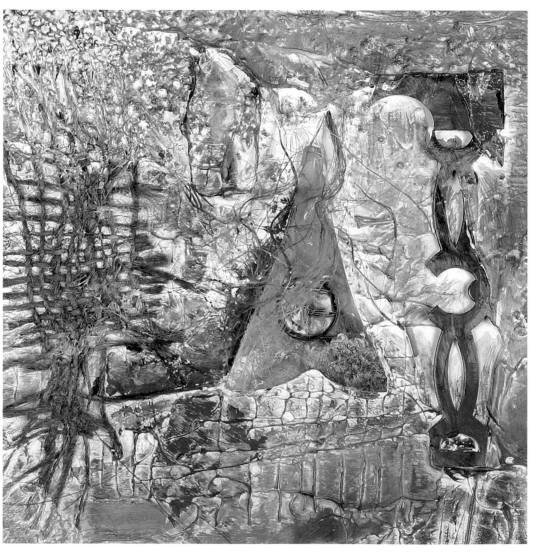

material, allowing it to be applied to non-rigid supports with reasonable confidence. Because of the enhanced solids content, the textures created with this medium can be very sharp, tough, and somewhat less flexible than those created with pure gel mediums.

This ground can be used under, in, or over other acrylic layers according to each painter's preference. It can be applied with any sort of brush or spreading tool, and, depending on the brand, can hold the texture of a high relief impasto to a hairline scratch.

gesso

The most effective way to seal or prime your substrate prior to painting with acrylics is to use an acrylic gesso. The most conventional and readily available type is a white gesso. This primer is made up of acrylic emulsion, calcium carbonate (precipitated chalk), and a good dose of titanium white pigment. Many manufacturers now also make gesso using carbon black, burnt umber, and unbleached titanium pigments. The white gesso can also be tinted with other colors to produce a colored ground, although the high titanium white content will result in the production of fairly pale tones.

Transparent gesso is a relative newcomer to the acrylic family. Generally it is produced in much the same way as white acrylic gesso without the titanium white pigment component. The resulting ground is translucent, toothy, and flexible. Using this ground allows the support to be visible while being effectively sealed. As it is quite clear, this type of gesso can be tinted with any acrylic color to achieve a richly colored backdrop.

Acrylic gesso is not different from its historical ancestor—which was made with animal skin glue and whiting—in that it provides a neutral, absorbent ground for the paint. Yet, unlike its predecessor, acrylic gesso is extremely flexible, contains no animal by-products, and it requires no time consuming, messy preparation. It flows easily out of the jar and can be brushed, scraped, or squeegeed onto the support. Artist quality gessoes have superior covering power and do not require more than two coats to

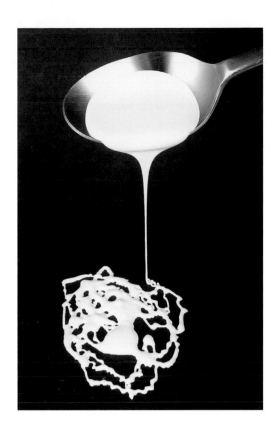

Acrylic gesso is pourable and has a self-leveling quality. It can be applied easily with a brush, squeegee, or roller.

make a solid ground. The chalk content gives the gesso its absorption and tooth, and lends it the ability to be sanded. To create a very smooth ground, apply the gesso in two or more layers, sanding each layer between coats.

The purpose of gesso is to seal the substrate and provide a non-yellowing, acid-free ground to paint on. Acrylics have proven to be notably resistant to aging and environmental damages. One of the best ways to prevent deterioration of the painting is to protect the paint from the support. The support itself can sometimes cause damage to a painting, either from the migration of evaporative particles into the paint film or from moisture penetrating the paint through the support. A good coating of gesso will protect the paint film at its base as well as increase the paint adhesion factor.

Gesso should not be regarded as simply a lowly primer, but also as a texture medium. It is not completely self-leveling, and as such when it is dripped onto a surface it creates soft relief. Because of the high chalk concentration in gesso, this is a technique best suited to more rigid surfaces.

finishing mediums

THERE ARE a variety of materials in the mediums' family that can be used as finishing coats for acrylic paintings. However, these materials are not often required, as there is no hard evidence so far that they are necessary or beneficial to the preservation of acrylic paintings. Thus, the choice to use them is an arbitrary one.

Several forms of top-coating materials are available, from mineral spirit–based to water-based acrylic urethane hybrids. Each of these has very specific application guidelines that are particular to their brand. When endeavoring to use any of them, it is best not only to read the label carefully, but also to consult any brochure information the manufacturer provides.

The acrylic alone will stand up extremely well to light and environmental exposure. Notwithstanding, as they have only been around for a little more than half a century and, based on accelerated tests and data collected over the last few decades, we can only speculate as to their longevity.

The acrylic varnishes and topcoats that have been developed can add a measure of resilience to the acrylic if used according to the manufacturer's instructions. While some varnishes are labeled as being removable, it should be noted that the solvents used to remove them could also affect the underlying paint.

Various mediums can produce an infinite variety of paint effects. Here acrylic mediums used in conjunction with one another work well to add visual and textural dimension to a primarily monochromatic surface.

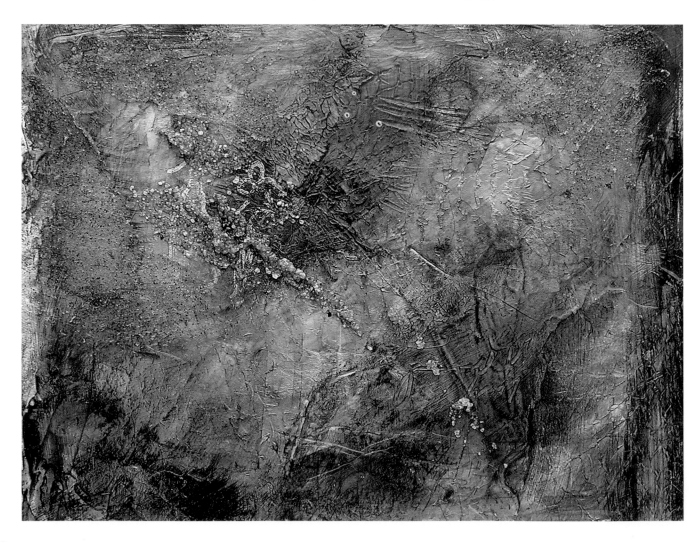

applying medium

GETTING A GRIP on the handling properties of each medium is the first step towards gaining a better understanding of how to apply them to painting processes. Each medium has a distinctly different chemical makeup. Depending on their viscosity and format, they exhibit variations in drying rates, sensitivity to water, and adaptability.

Every medium is designed to perform a series of specific functions. For the most part, they are interchangeable. They can be mixed together and applied in conjunction with each other. That is not to say, however, that they will always behave in a predictable or desirable way. Experimentation can create extraordinary paint effects, or disastrous ones.

The keys to successful medium manipulation are to become educated in their handling properties and to sustain the courage to improvise. That being said, there are some facts and guidelines to keep in mind that will minimize the potential for art catastrophe.

Take the time to test out your materials before putting them to use on any serious project. The thing to remember is that the rules which apply to any particular medium when used on its own will not necessarily apply when the medium is used in combination with anything else. This is particularly true when it comes to mixing brands. Various brands will have different sheen levels, viscosity, and handling properties. Acrylic manufacturers each produce acrylics according to a very basic recipe, however the choices of raw materials can vary by a large margin. The end results should all, theoretically, be compatible, however there is no way to know exactly who puts what in their chemical soup. Incompatibility is a gamble you take when mixing brands, but if you stick to artist quality products, that risk is much reduced. Testing your combination ahead of time is the best cautionary measure.

Follow the manufacturer's instructions. When used in accordance to the given instructions, each medium should behave as specified. Bringing in other media or using the medium in an experimental fashion can upset the fine chemical balance, sometimes causing unexpected results. Any such deviations could be deemed "happy accidents," but more often than not throw a wrench into the workings of a masterpiece. The basic message here is simple, when mixing mediums, always do a test patch before risking damage to your creation. Consider it a rough copy.

For optimum results, always allow for adequate curing time between thick layers of acrylic colors or mediums. Thick layers of medium need ample time to cure. While they become dry within a day or two, they will continue to clarify and cure for a period of weeks. When building layers it is not imperative to wait for the layers to be fully cured, as this can take up to several months. What is crucial is that the initial layer be allowed to dry long enough for it to receive the next layer. Very thick layers can take up to two days to be dry to the touch, whereas thin layers are touch-dry in minutes. As a rule of thumb, if in doubt always allow the paint to dry for a period of 24 hours or more where clarity is an issue.

There are many more mediums available today than have been mentioned in this chapter, and even more still to come. The mediums shelf is definitely one to keep an eye on as this is where the latest in acrylics technology will reveal itself.

CHAPTER 5
BASIC APPLICATIONS

All of the projects and techniques illustrated in this book have been designed with clarity and simplicity in mind. The object of these exercises is to provide painters with a basic understanding of acrylic technique, without being encumbered by subject matter or style. The end products have evolved spontaneously out of the process, and it should be understood that individual results will vary according to the materials used as well as the skill, imagination, and resourcefulness of the painter.

acrylic painting techniques

ACRYLICS CAN BE APPLIED in such a variety of ways that it would be presumptuous to narrow acrylic paint methods down to one or two. The more acrylics improve, the more they seem to be able to do.

The quick-drying property of acrylic paints is a boon to several techniques—glazing, layering, and mixed media work being the most prominent of these.

Glazing and layering can be accomplished over a number of hours rather than days, as it would with oil colors. Also considerable in its possibility is the ease with which acrylics bond to myriad surfaces. The adhesion factor is unlike anything that oil or watercolor paints can offer. Acrylic paints can be applied to more supports and surfaces than both formats put together. No other paint to date has been able to do this.

In this chapter are a few examples of some of the ways in which acrylics can be applied. While there are doubtlessly countless more methods of applying acrylic paints, I have pinpointed some of the more common practices. These can be viewed as jumping off points and can be tailored to suit individual styles and needs.

OPPOSITE: *Their ease of application and quick-drying abilities make acrylic paints the ideal choice for art in performance. Plein air painting can be tricky with acrylics. The sun's intensity can seriously cut back on drying time, particularly in hot, dry climates. Working with additional mediums and a retarding additive will provide a larger working window.*

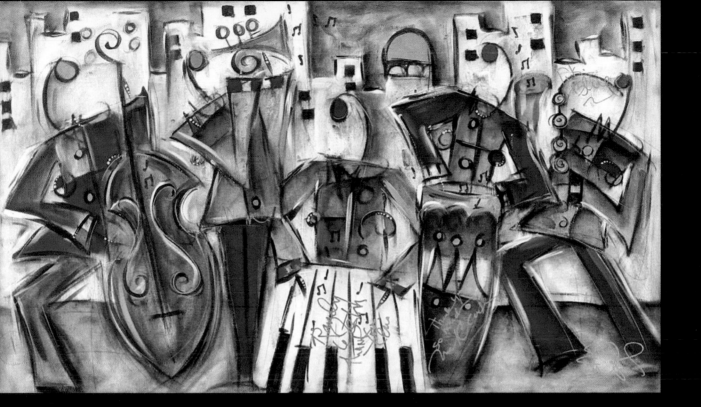

The new acrylics work well with my style of painting. For years I painted primarily in my studio. In the last few years, however, I began painting live at various venues, such as concerts, jazz clubs, restaurants, and such, as well as on television. Performance painting requires broad, sweeping strokes as well as a quick-drying paint, since I need to complete the canvas within the allotted time. The quick-drying properties of acrylics also allow me to layer colors continuously as I paint.

Eric Waugh

a la prima

With colors as luscious and vibrant as those in the modern acrylic palette, it is tempting to use them straight from the jar. And why not! The creamy texture of high viscosity acrylics and the soft flow of liquid colors are at their most resonant and rich when used a la prima. The lavish amounts of pigment they contain give the paint a deliciously deep appearance.

This is painting at its most decadent. Using neither water nor mediums as diluents, the saturated paints are as soft as warm butter to manipulate and are intensely responsive to the touch of a brush. When applied in thick quantities, they remain workable on the surface for several minutes, allowing for wet in wet blending and textural manipulation.

splatter *Colors and textures mix in dynamic splashes of paint flung directly from the jar or splattered with a well-loaded brush.*

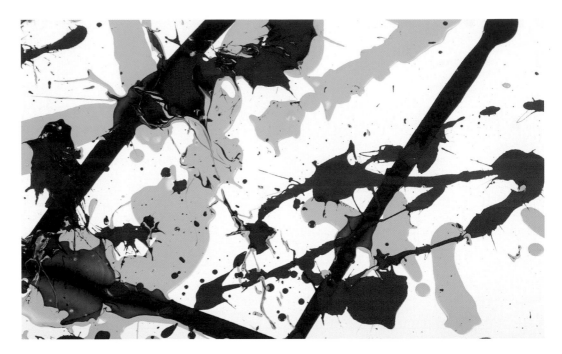

pull *Pulling multiple colors across heavy paper results in dramatic striated effects.*

drip *Thinned liquid acrylics or acrylic inks catch onto wet colors as they travel down an unprimed vertical canvas.*

OPPOSITE: *In Suzanne Charo's homage to the cave paintings of Lascaux, France, she emulates the feeling of stone and primitive tools by adding nepheline gels in transparent glazes and scratching into the surface with sharp tools. Her use of metallic pigments and bold texturing breathes life and opulence into these ancient images.*

sgraffito

Sgraffito is a technique that fits naturally into the acrylic vocabulary. This process is one that makes use of two layers of color, one dry, one wet. Wet color is painted over the dried underpaint, and, while still wet, it is scratched into with a tool to reveal the underlying color. If the area intended for sgraffito is large, a small amount of retarder and/or extra medium mixed with the acrylic paint will help guarantee an adequate working window.

Here, several layers of paint were applied and worked with a sgraffito technique. The uppermost layer of paint was scored with a sharp tool to expose the underpaint, adding a new color dimension and visual texture.

Tools for this procedure depend on the desired line width. Very thin lines can be achieved with painting knives, bamboo skewers, straight pins, or any fine-pointed device. Rubber-tipped paint shapers are a fabulous choice for achieving regular linear designs, while fingers can pull the paint into softer-edged patterns.

hard-edge painting

Acrylics are a natural for producing hard-edge color fields and details. Their quick drying capability paired with the low-tack quality of masking tape combine to create extremely sharp color and texture separations in a matter of minutes.

To have the cleanest results when using this technique, choose a masking tape that is sticky enough to act as a barrier to the paint. Press the tape firmly along the edge before applying the fresh paint. If taping over a previously painted surface, make sure that the surface is completely dry before using the adhesive material. If the paint is still even partially wet, there is a risk that all or parts of the paint will be lifted up along with the tape.

In both of these examples, hard-edge lines were produced by masking. Use masking tape to mask areas of flat color, as seen in the example on the left, or to separate flat areas of color by light relief, as illustrated on the right.

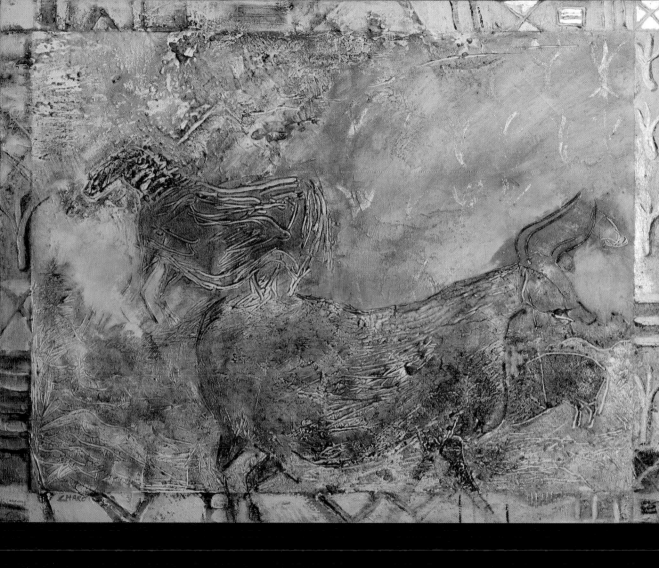

I love the tactile quality of acrylic paint. The creative process for me is about manipulating the paint so that texture and color become a more exciting element than the image. It's not about the theme, but the process of painting. Subject matter can get in the way of real creativity, which is about your interaction with the paint and the color.
Suzanne Charo

extrusion

In addition to using a brush, an extrusion technique can be used to draw lines with acrylic paints. This method of application is easy to master and control. The extrusion technique is ideal for incorporating linear details and text into a painting. Borders for liquid glazes and outlines for color blocks are easy to accomplish with extruded lines. Extrusion can also serve as an application procedure for precision adhesion and for creating relief textures.

A variety of tools can be used for extrusion, most of which are not manufactured with this process in mind. The kitchen is one of the best places to find extrusion tools. Pastry decorating equipment is perfectly suited for the job. The icing decorating bags, tips, and couplings are reusable and come in a large assortment of sizes and shapes. A plastic syringe can also be used, although the amount of paint it can contain is minimal.

Some liquid acrylics are packaged in squeeze bottles whose nozzles are perfectly shaped for extrusion. Bear in mind that liquid acrylics will create soft-edge, bas-relief lines, while higher viscosity paints will produce very distinct, solid lines.

The extrusion technique requires a great deal of paint. Because of this, it is advisable to mix colors with a gel medium or modeling paste in the interest of economy.

Crosshatching with an extruding tool achieves depth through relief.

Extruded acrylic "lace" held up to a blue sky. The layers of acrylic "string" bond together as they dry, creating a self-supported web of paint.

faux metallic surface

Various application techniques can be combined to spectacular effect. In this demonstration, the surface is first decorated with extruded lines then layers of metallic glaze are applied to create a faux metallic patina.

materials

- support (paper is used in demonstration)
- liquid gloss medium
- acrylic colors: sepia, Payne's gray
- iridescent colors: bronze, copper, silver
- interference green
- paintbrush

1 Squeeze the liquid gloss medium out onto your ground in random patterns. Allow the medium to dry overnight. Apply a light wash of transparent sepia and water, allowing some of the paint to pool around the raised medium.

2 Lightly dry brush with an iridescent color over the entire surface. Be sure to cover not only the relief gel, but some of the paper as well. Apply a second sepia wash. For added depth, apply layers of iridescent bronze, copper, and interference green.

3 To give the surface a more aged look, mix some Payne's gray with transparent sepia and water for a third wash. Once the wash has dried, dry brush lightly with more interference green.

4 For the final touch, apply a light dry brushing of iridescent silver. For a high gloss surface, add a coat or two of liquid gloss medium.

blending

ACRYLIC COLORS can be blended on the palette, or directly on the support using a variety of methods. With or without the addition of a retarding additive or acrylic medium, working rapidly is the key element to successful blending.

1 For the one-pass color blend, use well loaded brushes to apply the two colors next to each other.

2 With a wide, flat brush, blend the colors by applying light pressure in a single sweeping stroke.

blending with broken color *For a dynamic, painterly look, applying raw color in progressively varying tones directly onto the surface produces an optical color blend with a distinctive impasto texture.*

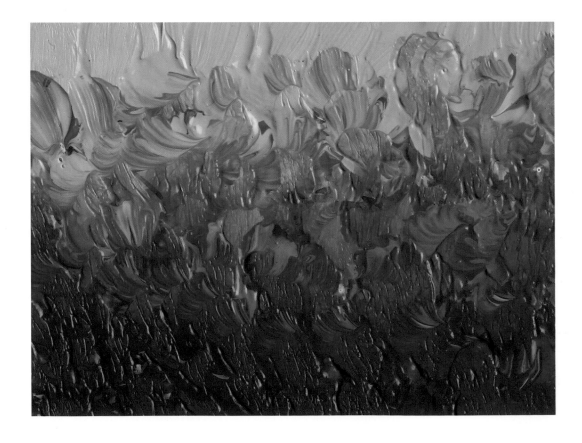

blending a la prima *Applied in thick quantities, acrylic paints are workable on the surface for several minutes, allowing for wet-in-wet blending.*

blending with liquid medium *Blending colors with a liquid or gel medium extends the open time of the paint, making wet-in-wet blending easier to achieve.*

blending with a sponge *In addition to brushes, a lightly dampened sponge can be used to softly blend colors. Lightly dab the sponge over the surface to create interesting textural effects.*

blending with a dry brush *One of the best ways to blend color is to use a dry brush loaded with very little color. Very soft bristle brushes are best to use for this technique, as hard, coarse bristles will create streaking.*

staining

SOFT, ATMOSPHERIC QUALITIES can be rendered by staining paper with acrylic colors. Staining can be achieved by applying, then quickly removing acrylic colors using a lightly dampened sponge.

1 Mix colors with a drop or two of acrylic retarder as you blend them on the paper.

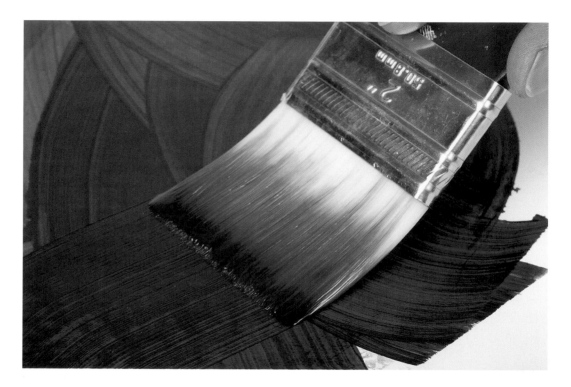

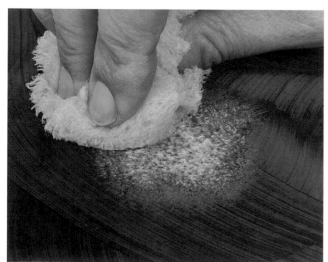

2 With a lightly dampened sponge, dab off the majority of the paint.

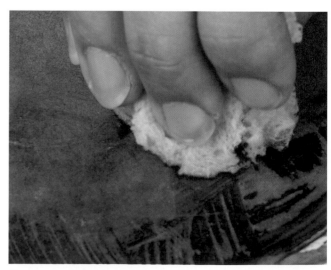

3 Use a clean side of the sponge to wipe off as much paint as you can. The remaining stain will be surrounded by soft edges of color that have dried, creating a random, striated effect.

feathering

THE FEATHERING TECHNIQUE relies on the drying speed of the paint on an absorbent ground. I have found this technique works well on paper and paperboard. The brush of choice for this technique is a wide, flat, soft hair paintbrush, such as a 2-inch Hake. When feathering, the partially dried paint will sometimes stay in place and sometimes be moved by the brush. This creates a light pulled look coupled with feathery brush strokes. Keep lightly brushing over the entire area with the dry brush until the paint is dry.

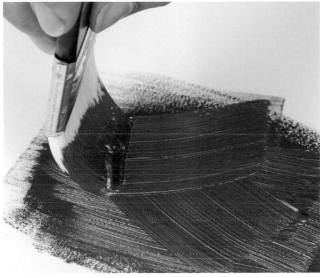

1 Apply the paint with a large format brush, coating the surface with rapid strokes in alternating directions.

2 Continue applying the paint using quick brush strokes, applying less and less pressure to the paint surface as the paint dries.

3 Swish a soft dry brush with light strokes across the surface of the paint.

4 The result of using a feathering method reveals some light brushwork combined with velvety smooth color planes.

underpainting

UNDERPAINTING is a means of delineating color areas and/or providing a luminous backdrop for progressive color layering and glazing. While I don't want to get into the specifics of the how's and why's and wherefore's of this practice, I would like to suggest some colors which lend themselves very well to underpainting.

When applying layers of transparent or translucent glaze, the best tones to use for the underpainting are those that are in the same color family as the top color. This is not to say that the under color should be a paler cousin of the top color, but rather that it should not cause the top color to shift unfavorably.

When thinned out in a light wash, most transparent acrylic colors exhibit radiant undertones that are bright enough to provide the necessary punch to shine through even multiple glazes.

Reds are becoming increasingly varied, and there are now some incredibly transparent ones that can be chosen for underpainting. The main thing to keep in mind when choosing a red for

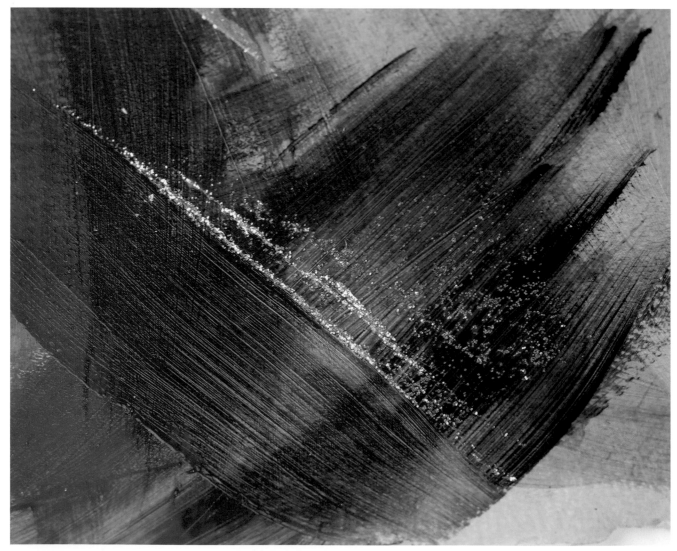

Indian Yellow underpaint with light passes of Phthalo blue, Quinacridone scarlet, Quinacridone violet, with acrylic glitter accent.

underpainting is to be aware of their undertone. For example, Quinacridone red has a bright pink undertone, while a light Naphthol or medium Cadmium will shift towards orange. Staying within the same tonal range will keep the color glaze from becoming muddy as the subsequent layers are applied.

When working with warm tones, I find that three of the most effective underpainting colors are Nickel Azo Yellow (vibrant, almost toxic sulphur yellow), Indian Yellow (an older pigment name which is now made synthetically,

has a characteristically orangey tone), and, for a more mellow mixture, I like the rich amber hue of transparent yellow oxide.

When cool is the intended mood, underpainting with any of the Phthalocyanine family is the way to go. These gorgeous colors range from a cool red-shade blue to an intense verdant green. The Phthalos always bring to mind a sense of the lush and aquatic. If a cooler, more celestial tone is needed, go with a cerulean, ultramarine, or cobalt tint.

seeing the light

Making use of the newest members of the acrylic family—the iridescent, interference, and glitter colors—reflective under- painting adds a burst of illumination. These types of colors provide more than just a tonal ground, they capture and bounce back light waves and add an ethereal luster from within. The most dramatic way to use them is coupled with glazes that are made with very trans- parent colors in low pigment concentrations. The less pigment there is, the more light can be reflected through.

A glaze of Phthalo blue over iridescent silver and iridescent deep gold.

interference colors

Interference colors add a gorgeous duality to glazes. As they are naturally quite transparent, these colors are ideal for adding dimension and resonance. They are best used in conjunction with transparent colors that complement the primary tone of the interference color. This allows the complementary color to fully develop as it blends optically with its complement.

Interference colors are most noticeable in three-dimensional applications. In thick glazes the play of light bouncing through them produces a subtle and enigmatic aspect that cannot be achieved by any other means with other types of color. Used in small quantities the effect is like that of mother-of-pearl viewed through moving water, or a glimpse of the chatoyancy of a cat's eye.

glazing mediums

The best mediums to use for creating clear, glowing glazes are transparent gloss mediums. All acrylic gel and polymer mediums are suitable for glazing, however, the glossy format mediums dry with a clarity that is superior to that of semi-gloss of matte format mediums.

There are mediums that are specifically labeled as glazing mediums. These are usually polymer mediums to which a small amount of retarder has been added to boost blending time. Retarder and flow-release additives can in fact be added to any medium or color for this purpose and therefore glazing is not limited to the use of any one specific medium. (Note that it is of particular importance to abide by the proper drying guidelines when using thick or textured gel mediums.)

Use gloss mediums exclusively for layering. Semi-gloss or matte mediums will gradually cloud a glaze. They can be used as a finishing medium when a duller sheen is desired.

mixing and applying

When mixing a glaze always test the color first to verify the tint strength. As glazes employ a large amount of medium (which appears white

Apply successive, thin layers of transparent glazes and medium to create surfaces of glowing, vibrant color.

when wet), the wet glaze will appear drastically lighter than its dried state. As the acrylic resin dries very clear, the color it is tinted with will dictate the glaze color absolutely without impediment from discoloration.

The most effective glazes are those comprised of successive, thin layers of transparent color and medium. Layers of thin glaze will dry rapidly and thus subsequent layers can be added quickly. In addition, thin glazes have a tendency to clarify more completely than thicker ones.

Thick glazes must be applied in successive layers. Each layer must be allowed to fully cure before subsequent layers are added. This can take anywhere from several hours to several days, depending on the thickness of the applied medium and ambient temperature and humidity of the room.

When a glaze made up of a heavy-bodied or high viscosity medium is applied too copiously,

the water will not be able to completely evaporate. Inhibited water evaporation will cause incomplete clarification of the medium, thus creating a cloudy to fully opaque paint layer.

A fully cured medium or glaze will be apparent by the clarity of the paint film. Using isolating coats of clear medium between layers will enhance the depth of a glaze.

specialty mediums

Specialized mediums such as Nepheline gels and other clear textured gels can be used to create textured glazes. They are clear enough to allow the tint color to shine through unimpeded by the particulate granules.

Use a self-leveling medium, such as self-leveling gel or low viscosity polymer medium to create smooth, texture-less glazes. The glazes will be particularly smooth if tinted with liquid, rather than higher viscosity colors.

Adding successive layers of thick transparent glazes over extruded textures until the surface becomes almost completely smooth produces exceptional depth. To further enhance a deep glaze, begin with lighter colors and end with darker tones.

ALTERNATIVE APPROACHES

Today's acrylics encourage painters to experiment beyond the preconceived notions of what paint is and how it can be applied. Be adventurous. Explore the alternative world of acrylic paints by making soft sculptures, prints, and more.

breaking barriers

THIS IS WHERE the real fun begins. In this chapter I will show by example some fresh new ways of manipulating acrylic paints and mediums to achieve diverse surfaces, textures, and moods. Acrylics can even be manipulated to mimic the qualities of other paint formats, including watercolor and oil. Highly adhesive when wet, flexible when dry, and compatible with a wide variety of other media, acrylics are more suited to radical improvisation than all other art materials. Bursting through the barriers of convention, here are some suggestions and examples of improvisational approaches to working with acrylic media.

RIGHT: *This acrylic sheet was given structure with embedded florist wire, allowing it to hold a cylindrical shape.*

OPPOSITE: *Artist Marjorie Minkin uses Lexan (a high performance thermoplastic) as a transparent support to create incredibly dynamic relief work, as seen in this piece entitled* WU T'ung Tree, *2001.*

I apply acrylic paint and resins to both the front and back of heat-formed sheets of plastic, often pouring the color diluted with medium in the channels created Applying multiple layers without losing the translucency of the colors was difficult before the new acrylic mediums were invented Now that the new acrylic mediums have been formulated to dry clear, I am able to utilize these products with recently developed acrylic colors, such as the iridescent and interference paints. Combined with the reflective topographical surfaces of the plastic, these new acrylic colors and translucent mediums help me to capture the ephemeral qualities of light in the natural world.

Marjorie Minkin, The New New Painters

the mimic

Create soft washes with fluffy natural hair watercolor brushes. Saturated acrylic colors can be thinned with more than 90% water to create thin washes that will absorb readily into cotton rag papers.

ACRYLIC PAINTS have a face of their own, but through careful orchestration they can be made to look like something entirely different. The projects outlined here show how the artist can give their acrylic painting the eerie depth of an encaustic painting, the whimsical fluidity of a watercolor, or the satiny resonance of oils.

As adaptable as they are, acrylics do not have a magical ability to morph into a different material. Nevertheless, with the use of mediums, the right tools, and an open mind, they can be manipulated into mimicking their appearance and texture. The idea is not necessarily to

ape the technique, but instead to carefully work with acrylics to achieve the overall appearance of the other media.

watercolor

Playing around with acrylics and water can be frustrating at first, as the brightness of the pigment may seem garishly vivid relative to traditional watercolors. The trick to successfully work acrylics with water is twofold: dilute the color drastically and stick to a transparent palette. Superior quality acrylics are produced with very finely ground pigments that will not

The three process primaries—yellow, magenta, cyan—blended with a watercolor technique.

appear grainy when diluted with water. Of course semi-opaque or opaque colors can be used, but keep in mind that they will partially or completely obscure underlying tones.

Watercolor tools and techniques can be used to create watercolor-like effects with acrylic paints, including using soft bristle brushes and masking fluid or tape, and working on rag paper from a dry to wet state. What you need from the acrylic shelves are the thinnest paints you can find. Liquid acrylics are ideal, and acrylic inks are perfect. As for mediums, a low-viscosity liquid polymer medium, in matte or gloss, mixed with

a drop or two of retarder is useful for extending color, although for this type of application water can be used in place of a medium.

The one area where painters *must* stray from watercolor technique is when blending color. As acrylics are not resoluble, the methods for blending are indirectly by layering successive tones or directly by working wet into wet.

You will find that if it is sufficiently diluted, acrylic paint will behave in much the same way as a watercolor. The loose, fluid pigment will float and absorb into the grain of the paper, creating soft to dramatic sweeps of color.

This design was painted directly onto a raw, damp canvas for a watercolor effect.

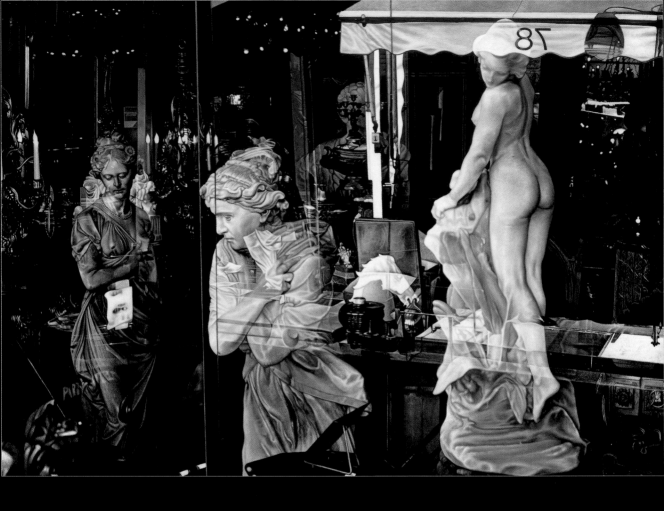

In order to achieve the depth of color required from the images I work from, I use about a thousand layers of acrylic, speed up the drying time with a blow dryer, and add layers of gloss medium between color glazes to add brilliance and depth. Essentially, I am creating works that resemble traditional oil paintings by using a process that is made more efficient with the use of modern acrylics.

Barry Oretsky

oil

Words that come to mind when describing the look of an oil painting are: lush, luminous, saturated, robust, and satiny—words that could just as easily describe an acrylic painting. The real difference between an oil painting and an acrylic is oftentimes perceived as being one of technique, rather than that of surface appearance. Traditional approaches like glazing and subtle color blending were once solely the mark of an oil painting, however, now everything from their luster to the chroma can be successfully mimicked with acrylic colors and mediums. Working with semi-gloss mediums for a satin finish and strong transparent colors in a high viscosity format are the beginnings to this end. Beyond that, the emphasis lies in keeping glazes transparent and creating soft color blends with the aid of retarder or acrylic gel and liquid mediums. Adding a small amount of warm transparent yellow can also add an amber tone to the overall painting, giving it the appearance of an aged oil.

encaustic

Encaustic painting is an ancient technique, based on working with wax as a painting binder and medium. Although wax can melt or bloom (show mildew), there are encaustic paintings that have endured for centuries when kept under pristine conditions. Acrylic paints can imitate the semblance of encaustic, and although it is as yet undetermined how long they will endure, they will not melt away under hot lights or be prone to the ill effects of mildew. And working with acrylics wins out over traditional encaustic techniques, which involve hot plates, torches, oil colors, and solvents.

Making acrylics look like wax and pigment is actually easier than one would assume. Basically, as the acrylic emulsion dries very clear and glossy, the idea is to "murk it up." To simulate encaustic with acrylic, first look for a semi-gloss or matte medium with a self-leveling quality. This type of medium dries with the translucence and smoothness of wax. To give it a bit more opacity or the amber tones of beeswax, add miniscule amounts of warm white or Naples yellow (hue). The medium can be manipulated at different stages of dryness to give the appearance of melted, scored, or distressed wax. Color can be mixed directly into the medium in its wet state or rubbed onto it when dry. The most luscious surfaces are made with thick layers of colored medium, and although they may have the look of an encaustic painting, they are emphatically acrylic.

OPPOSITE: The Three Graces (2002), by artist Barry Oretsky, has the look of an oil painting but was actually made from acrylic colors. Oretsky uses traditional glazing techniques and an educated use of color to achieve luminous canvases of startling depth and detail.

Thick layers of both opaque and transparent color, coated with repeated layers of thick gel, give the skin of this painting a waxy appearance, further accented by the bold use of a glossy black oil stick.

acrylic transfers

AN ACRYLIC TRANSFER essentially grabs the ink layer of a copied or printed material and embeds it into the acrylic film. To transfer, the image is first covered with a clear-drying acrylic medium. Once the acrylic has dried, the paper is rubbed away, leaving the ink safely lodged in the acrylic sheet. Today's copiers and printers produce excellent facsimiles, virtually indistinguishable from the original. Look for printers using archival or lightfast inks, so the colors will be less likely to change over time. (This is less of a concern when dealing with black-and-white images.) The acrylic film itself acts as a barrier from water, air, and some UV light radiation, further preserving the printing ink.

1 To make an acrylic transfer, apply a layer of acrylic medium over the printed sheet, here a photocopied sheet of music. Let the medium dry completely.

2 Wet paper, then rubbing gently with your thumbs, remove all the paper from the gel, being careful not to rub off the ink layer. Set the transfer aside to dry.

3 If there are light or blank spaces within the transferred image, it can be very effective to apply the transfer to a colored ground. Press the transfer on a wet background to create random patterns in the underlying color.

4 By applying layers of acrylic medium, multiple transfers can be combined to create a finished work of art. A finishing touch of light gold on this gloss gel acrylic transfer brings out the ridges and helps to visually blend it into the background.

acrylic transfer painting

Sometimes there is an incredible photograph, timely news-clipping, or magazine spread that simply must become a part of your painting or collage, but the original cannot be sacrificed, or is too impermanent to include. Acrylic sheet transfers can help you to overcome this obstacle.

materials

- flat palette or glass
- photocopy or print
- gel, liquid, or self-leveling gel medium
- liquid acrylic colors (to blend with print)
- flat brush or palette knife
- squeegee
- masking tape (optional)
- shallow basin

1 Fix the image onto a flat palette or glass (the best palette for this process is one to which the acrylic film will not adhere) with a few brush stokes of medium. If using a glass palette, adhere the edges of the image to the glass with a few layers of tape to produce a barrier that will hold in the acrylic medium.

2 Using a flat brush or palette knife, apply a thin, even coat of medium to the entire image, extending slightly beyond the edges. If pouring a medium, spread the acrylic evenly over the image surface.

3 Allow the gel to dry for at least 48 hours. Allow thicker films to dry for one week or more. Detach the image from the palette and immerse in water until the paper is saturated. (Do not soak the paper for longer than 15 minutes as over-soaking may cause the medium to permanently opacify.) The wetted medium will become slightly milky, but this will clear up once it has re-dried.

ALTERNATIVE APPROACHES

- painting surface
- printing paper
- liquid acrylic colors
- acrylic retarder
- paintbrush

DEMONSTRATION 5

monotype

A monotype can be pulled from just about any smooth, flat surface. The process is very simple. Essentially, paint is applied onto one surface and then pressed onto another, leaving a textured impression on the new surface. In order to demonstrate this technique I have used a small pane of glass, though alternatively you can use any flat, non-absorptive surface.

1 On a clean piece of glass, quickly sketch out your design. The paint should be of a liquid consistency with a touch of retarder added to keep it from drying before it reaches the paper. Keep the colors well apart from each other unless you intend them to blur into one another.

2 The design to be printed should be kept as simple as possible as laborious attention to detail will result in dry paint that will not transfer to the surface.

3 Gently place the glass plate onto the paper. If desired, paint the paper ahead of time to provide a higher contrast background. Gently lay your hand over the glass and apply even pressure.

4 Carefully lift the glass from the paper in one smooth motion, as shown.

5 If desired, paint another design on the cleaned glass to add to the composition.

6 Follow the same steps to print the next design over the first, applying gentle pressure.

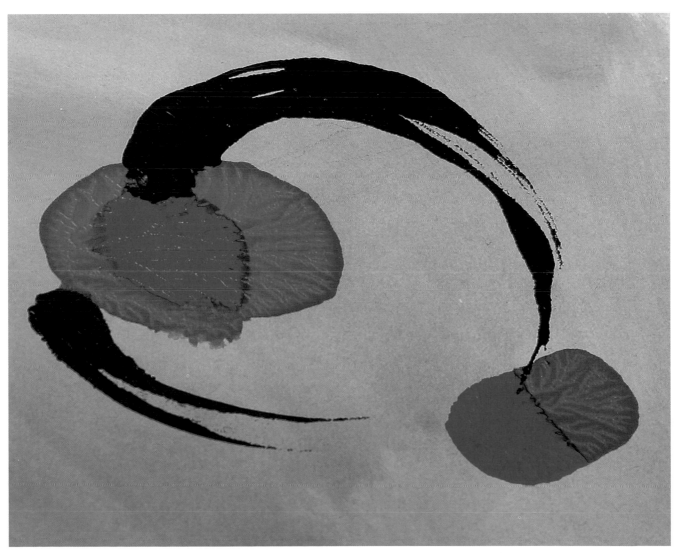

7 The finished print. The lifting action of glass from paper tugs at the wet paint, leaving a subtle veining in the paint surface. Note how some areas of the paint had partially dried on the glass, leaving gaps in the print.

soft sculpture

WE TEND TO THINK of paint as something that must be applied to a surface, and that's all most paints are capable of, until now . . .

Acrylics are a plastic; they dry to form a solid, flexible, transparent skin. While we know that these qualities make for a durable paint medium, what may be a surprise is that they also give acrylics the ability to be used as sculptural tools. Without the sustenance of a support, acrylic paint becomes so much more than a

Gloss gel medium strands shaped into a fine spider web pattern. The thin filaments were extruded onto a non-adhesive palette and pulled off when they were clear and dry.

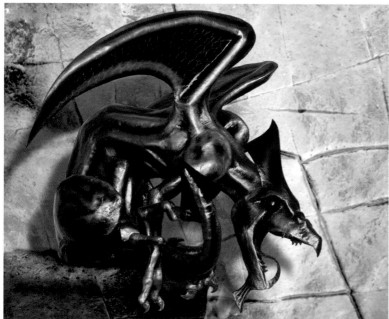

This papier mache sculpture by Monique Robert is the ideal type of surface for showing off the ethereal luster of interference colors and the capacity for acrylics to coat three-dimensional objects. On the smooth surface of this gargoyle, interference colors highlight the curves of each muscle, accentuate the sculptural mass, and make the skin seem to glisten. The trick to working on a surface with diverse planes like this one is to keep the paint fluid enough to discourage visible brush strokes, but not so thin that it will drip down or pool. Liquid acrylics thinned with a low viscosity medium and applied with a moderately soft bristle or foam brush work very well.

mere coating. You can whip it, carve it, slice it, dice it, smear or spread it into a solid mass or sheet. And once you have done that, you can improvise to create incredible soft sculptures.

The warm acrylic film will stick very well to itself, as well as to other things. It can be stretched, stuck, or poured onto a surface to coat an armature or object. Sheets of dried acrylic colors and mediums can be used to produce translucent and rigid sculptures that can stand alone or be made to appear to drip from the walls and ceiling.

Creating a freestanding, three-dimensional acrylic paint sculpture can be a tricky process for two reasons. First, the acrylic paint film is a soft, pliant material. In order to give the film enough rigidity to hold its shape, the acrylic sheet must be reinforced with some type of internal support. The support can be a flexible one, such as a pliable wire, or a rigid one, like a bamboo skewer.

The second challenge to creating freestanding sculptures is that acrylics are a thermoplastic, and thus the ambient temperature has to be taken into account. Heat will cause the film to sag, stretch, and stick to itself, while cooler temperatures will make the acrylic stiffen and be susceptible to breakage. The solution here would be to build three-dimensional projects at room temperature.

Sculpting with acrylics presents some unique possibilities. The acrylic sheets can be made to look like fused glass by combining acrylic colors in different stages of drying, or items can be embedded into the soft acrylic to accent a sculptural work.

make it stick

For the purpose of sculpture, it is best not to dilute the paint with water. The more acrylic present in the paint, the more durable and cohesive the paint film will be.

acrylic sheets

The elasticity and flexibility of acrylic sheets allow an artist to wrap a variety of supports, whether wire frames or finished sculptures. Much like cling film, the acrylic will stick to itself and can be molded to any form it is stretched onto.

To make an acrylic sheet you will need a palette that will repel the dried acrylic. There are new palettes available in some art supply stores that will not bond with acrylics. If those cannot be sourced, a clean glass palette is a suitable alternative.

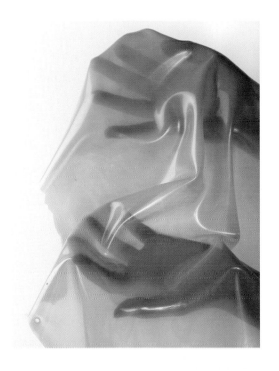

Pour a quantity of self-leveling gel tinted with color on the palette, spread the acrylic, and leave it to dry for a few days. Once dry, the acrylic sheet (left) can be cut easily with a regular pair of scissors (above). The sheet can also be carved into more detailed shapes with a craft knife.

To create a sheet with a lacy pattern, pour a thin stream of colored gel onto the palette using a swirling motion. Be careful not to let too much gel accumulate in one place. Let dry for a few days.

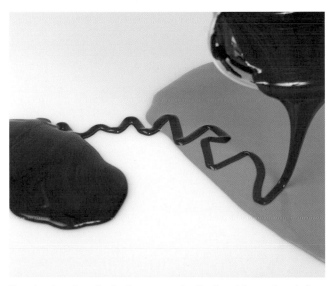

For a two-toned acrylic sheet, pour a contrasting tone into a wet pool of color. Be sure to first mix each color with a large amount of self-leveling gel medium.

reinforcing with florist wire

Stainless steel florist wire comes in a variety of thicknesses and is extremely well suited for making pliable armatures for acrylic sculptures.

RIGHT: *In order to add structure to acrylic sheets, any form of stainless steel wire or mesh can be used to form an armature.*

1 To create a support for an acrylic sheet with florist wire, pour an expanse of acrylic and self-leveling medium on a nonstick palette, as described on page 131. Place straight floral wires in the acrylic sheet at equal intervals.

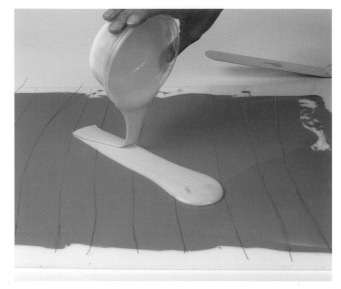

2 Once the first layer of acrylic has dried around the wires, it is a good idea to add a second layer on top to seal the wires in and to cover up any bits that are sticking out. The second layer can be the same color as the first or a new color.

3 Use a large spreading tool to spread the top color (in this example I have used two monochromatic tones) over the entire surface. Add enough tinted medium to fill in any imperfections or gaps to give the acrylic sheet a stronger constitution.

4 As the two layers dry and bond together, they trap the metal wires into place. Once dry, the sheet can be bent and manipulated to conform to the sculptor's whim.

reinforcing with wire mesh

Craft wire mesh is a pliable modeling material that bends, stretches, and holds three-dimensional forms. Made from rustproof metals, wire mesh offers strength and flexibility as a modeling support. It is available in sheets and rolls in arts and crafts stores.

1 To create a wire mesh support, attach the craft mesh to a glass sheet or non-adherent paint palette, using enough tape to hold the mesh down as flat as possible. Pour the tinted self-leveling gel medium liberally over the mesh.

2 With a large spreading tool, spread the tinted gel to make an even film. Once the gel has dried, slice the excess off with a blade or trim it off with scissors.

3 The gel will sink through and around the wire mesh. Once the reinforced sheet is dry, it can be easily cut into sheets, and folded and bent to the desired shape.

4 Reinforced acrylic sheets will remain workable as long as they are at room temperature when being manipulated. If rolled up for storage, it is best to put a layer of butcher paper between the layers, as a too warm environment may cause the film to stick to itself and the entire sheet may be ruined.

special effects

IMPROVISATION and experimentation can generate fabulous effects. In addition to traditional brushes, paint can be applied to surfaces using sponges, rolled up balls of paper or fabric, or even splattered on with an old toothbrush. Paint can be applied and then scrubbed off a surface, or a resist can be used to reveal stunning designs when paint is added. Here are a few suggestions that may help ignite your imagination.

A design created from a paraffin wax resist.

Jute fibers tied to a foam roller produced this lively surface pattern.

A dry sea sponge was used here to apply layers of color.

A balled up piece of paper was used to press paint onto this surface.

A small pane of glass was pressed into wet paint to create this interesting veined blend.

Speckles of color applied to a surface by thumbing an old toothbrush loaded with paint.

A thin layer of paint was let dry and then distressed with a scouring pad.

Rolling paint over a cluster of kitchen string leaves a lively impression.

additives

When substances such as bleach, salt, or mineral spirits are added to acrylic paint the effects can be quite intriguing. In a similar fashion, a surface can be given texture by layering on additives such as sheets of plastic or thin acrylic.

Bleach dropped into wet wash and pulled off with an absorbent cloth.

Mineral spirits dropped into a layer of wet acrylic color.

Plastic wrap spread onto wet paint and pulled off to reveal a vein-like surface texture.

Polymer gloss medium dropped into a deep blue wash.

Here, color was added into a wet gloss medium and then partially removed with an absorbent cloth.

Salt sprinkled onto a surface of wet acrylic.

Gold glitter dropped into a wet wash of color makes this surface sparkle.

Drops of liquid cobalt teal in a Prussian blue wash.

A thin acrylic sheet layered over a surface coated with acrylic color.

try this!

Score a fully cured, thick layer of color with a sharp craft knife. Swipe color over the cuts, then quickly rub it off with a very lightly dampened cloth, pushing the paint into the fissures. The color-filled incisions can add edgy highlights to a composition.

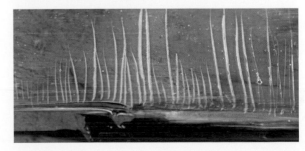

mixed media

ABOVE: *Charcoal applied over tinted nepheline coarse gel.*

BELOW: *Wax crayon over an acrylic surface.*

OPPOSITE: *Photographs make wonderful collage elements when married into an acrylic composition with harmonious colors and accents, as in this painting by Lori Richards.*

MIXED MEDIA ARTWORK bridges the gap between fine art and fine craft. Acrylics are at their most useful here, as a ground for other materials and as a glue that makes oil-, solvent-, and water-based mediums compatible with each other. Acrylic paints are your passport to the improvisation party. They provide a perfect opportunity to explore new creative territory and diversify your style.

Hearing all the hype, it may seem that acrylics are the invincible omni-paints, but as with all things, there are some boundaries that are prudent to observe.

The first element to consider is that acrylics are water-based. Painted over a resoluble medium (such as watercolors, pencils, or crayons) or a loosely bound medium (charcoal, soft pastel, graphite, and conté) the acrylic will either rewet or displace and blur the medium, thus changing its appearance. While it is best then to stay with water-based materials in mixed media applications, you can use an acid-free spray fixative to get around this dilemma if needed. What this does is decrease the amount of pigment bleed when using water miscible mediums in conjunction with acrylics. Charcoal and other drawing materials that leave little or no binder on the surface must be fixed,

unless you want the effect of powder being drawn into the acrylic layer.

The second consideration is that oil and water do not mix well; therefore, oil and acrylic paints should not be mixed. However, that is not to say that they cannot exist within the same painting. The rule to follow here is oil over acrylic, and never the other way around. Acrylics need to form a bond with the under-lying paint or support. As they will not stick to oily or greasy surfaces, painting acrylic over oil will not be successful, unless the intention is to use a wax- or oil-based product as a resist. Oil paints, oil sticks, and oil-based pastels will happily form a permanent bond on top of an acrylic underpaint, and to do so can produce beautiful and luminous effects.

collage

Acrylic mediums and colors can be used to fuse collage materials and glue objects into a surface. Rubber stamps and objects can be pressed into the semi-dried medium to leave an imprint. As acrylic mediums have a neutral pH, they are useful for scrapbooking, photo albums, and framing.

The fusion of diverse art media or objects is never entirely predictable, and more often than not there is no real guarantee that any of it will actually work or last. Artistic creativity sometimes thrives on ignoring logic in pursuit of new, better ways for creative expression. The result can be a fugitive work that deteriorates within a year, or it could be the birth of a new art media prototype.

Aside from the conservation issues of combining media, there are no real limitations on what you can do with acrylics, although there may be some combinations that will misfire due to flagrantly inappropriate product blending. But whether the outcome is good or bad, it's all a matter of self-expression, aesthetics, and pushing the envelope for the sake of art.

ALTERNATIVE APPROACHES

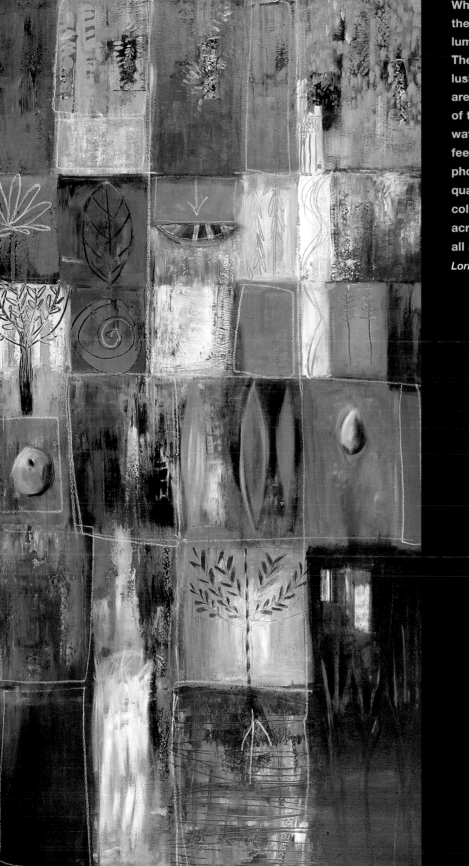

Why I love the new acrylics . . . the colors are seductive and luminous, with loads of pigment. The chromatic saturation is as lush as oil paints and they just aren't as toxic. I love the versatility of the paint and mediums—from a watercolor effect to an encaustic feel. Because I do a lot of collage, photomontage, and layering these qualities are perfect. It's all about color and flexibility for me. These acrylics are freeing and addictive all at once.

Lori Richards

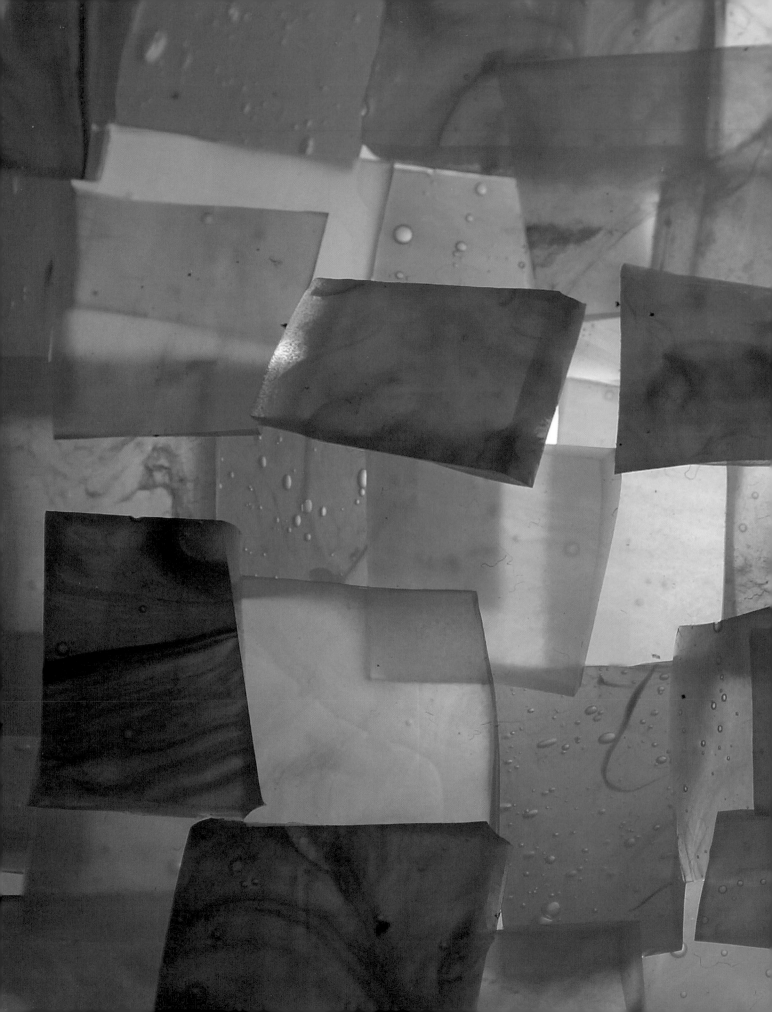

DECORATIVE OBJECTS

When has paint called out to you? Lured you into a frenzy of creative activity? I have found that people confronted with a fresh batch of acrylic colors are given to sudden outbursts of expression. Much flinging and splashing is going on, and the noise is resonating in galleries, studios, and even around the home with lively and colorful decorative objects adorning our walls, floors, and tabletops.

making things

ACRYLIC PAINTS are fast becoming the backbone of the art, craft, and folk art world. They are exuding their way into many aspects of modern art and insinuating themselves into our homes, offices, and outdoor spaces. The variety of suitable supports for acrylics makes them the ideal choice for creating hard-wearing decorative home accessories. While we've all seen faux-finished mantles, trompe l'oeil murals, sponge-painted walls and stenciled armoires, floors, lamps, and other decorative objects are equally prime for painting. Acrylic colors sealed with a sturdy topcoat create tough, washable, water-resistant, and fade-proof surfaces that will service your walls, floors, furniture, and accessories for years to come.

Sheets and tiles made from dried acrylic colors were used to make this mosaic lamp. No adhesive was required to bond the acrylic layers to the lamp, as the heat of the interior bulb was enough to keep the softened acrylic adhered to the glass.

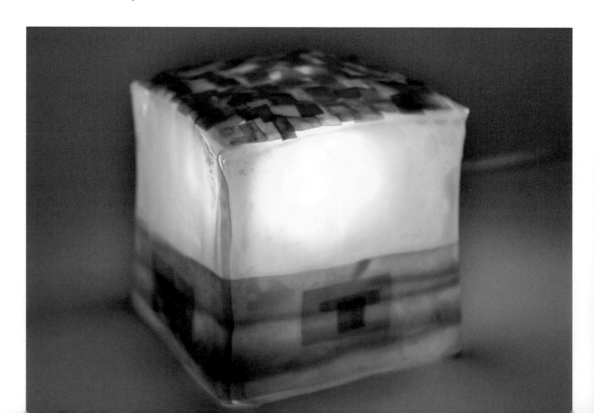

floors

NOW IT'S TIME TO DEAL with what lies beneath . . . those humble wooden plank, dull concrete, and pedestrian tile floors. Give ordinary floors an extraordinary finish with acrylic paints and mediums. Regardless of whether you are painting an entire floor or simply stenciling a border, the brilliant range and variety of acrylic colors will satisfy your decorating needs.

The dazzling array of transparent, semi-opaque, and opaque acrylic colors provides all the inspiration needed to create stunning surfaces unparalleled by any made with average household floor paints. Iridescent and interference colors can wildly change the appearance of any floor, while layers of glowing transparent glazes can add remarkable depth and luster. Acrylic mediums, such as modeling paste, self-leveling gel, and nepheline gel provide a multitude of texture options, so you can achieve just the look you want. Brush, roll, or splash paint on; whichever way you choose to use them, modern acrylics will give your floors a touch of individuality along with the added durability, weather resistance, and color stability of a contemporary artist's medium.

While design is particular to individual taste and style, there are some guidelines that can help floors and floor coverings harmonize with their surroundings. Simplicity, repetitive patterns, and colors that interact well with the room are three things that can help marry a floor to its environment.

materials

- heavy primed canvas
- topcoat (sealant)
- foam rollers
- very wide, flat paintbrushes
- polymer medium
- liquid acrylic colors: red, fuschia, orange, black, green
- white gesso
- pencil or water-soluble crayon
- ruler
- masking tape
- stretcher

DEMONSTRATION 6
floorcloth

The ultimate in durable, washable, and stain-resistant floor coverings, the canvas floorcloth has been making a comeback. While the most common way to prepare a canvas surface for painting is to use an acrylic gesso, a semi-gloss or matte polymer medium can also be used to seal the surface. Please note that floorcloths, like table runners and mats, are made to be flexible. For this reason, I advise strongly against using a white housepaint primer, as it is made to be used on rigid surfaces and lacks the flexibility found in artist acrylic grounds.

1 To transfer a design onto canvas, first draw your design on a piece of grid paper. Then, measure and lightly pencil mark a grid directly onto the prepared canvas.

2 Transfer the drawing to the canvas section by section. Sketch the design outlines with a pencil or water-soluble crayon. (Soft pencil marks can be erased easily from a primed surface with an eraser.)

3 Mask the borders of large areas of flat color to keep the paint from bleeding from one color area into another.

4 Apply a base color coat with a foam roller or large, flat brush. To decrease the surface texture, the paint should be thinned with water or a low viscosity medium.

5 Fill in color areas one at a time. Wait for each color to dry before applying the next. For our project, the red background was painted first, followed by the fuschia petals, the orange details, the black hearts, and finally, the green leaves.

6 To finish, outline the petals and leaves with black. Before adding any varnish or topcoat to the finished floorcloth, paint the side edges of the canvas to seal them.

7 Apply a matte polymer glaze to the painted surface. Let the cloth dry for at least 48 hours, then apply two to three layers of topcoat. As the sealant dries, keep the floorcloth on its stretcher to discourage the canvas from curling and buckling. Remove the cloth from the stretcher, cut off excess material, and hem the edges with polymer medium.

care and storage

To further protect the floorcloth from water and dirt, tape down the edges and apply one or two thin layers of gesso or polymer medium. Keep the cloth taped down until the layers are dry. Occasionally wipe the surface of the floorcloth to remove dirt build-up and to keep it looking fresh. When storing a floorcloth, it is best to keep it rolled on a rigid tube. Unroll the cloth at room temperature to avoid cracks or tears that can be caused by the acrylic hardening at cold temperatures.

acrylic mosaic

A MOSAIC CAN BE MADE from acrylic tiles in a variety of glowing colors. Acrylic tiles are more flexible than glass, ceramic, or stone tiles, but what they lack in rigidity they more than make up for in sheer variety. With the use of mediums, texture gels, colors, and additives, tiles can be produced in any shape and form.

To make acrylic tiles for mosaic work, use a sharp craft knife or scissors to cut sheets of tinted acrylic gel into strips and then into squares. (If desired, recycle paint leftover from earlier projects to make the acrylic tiles.) Once you understand the basic technique, feel free to use your imagination to explore the creative possibilities. You can texturize the tiles or press designs or embed objects into them. Combine the tiles with acrylic sheets to create designs with areas of solid and broken color. Add marble dust or sand into the tiles if you want to give them rigidity, or leave the tiles clear, like blocks of colored gelatin or stained glass. Use acrylic tiles to decorate lamps and lampshades, as well as tabletops, trays, and other surfaces with colorful mosaic designs.

An assortment of acrylic tiles made from bits of leftover dry acrylic.

mosaic lampshade

Acrylic tiles are essentially solid paint cut into chunks. For this project, I cut paint leftover from other projects into strips, and then into smaller shapes. The tiles are simple, colorful, and ready to be used for mosaic work.

materials

- glass ceiling lampshade
- acrylic tiles in assorted colors (see page 146)
- gel medium
- liquid polymer medium
- titanium white acrylic paint
- water-soluble crayon
- soft-tipped spreading tool
- soft cloth

1 On the underside of the lampshade, use a water-soluble crayon to sketch out the design. Once the tiles are set, this can be washed off with a wet rag.

2 Apply a dab of gel medium directly to the glass to secure the tiles in place. It is best to use a thick gel, as the thinner liquid mediums will dry too quickly and do not have enough mass to keep the tile from sliding off the glass.

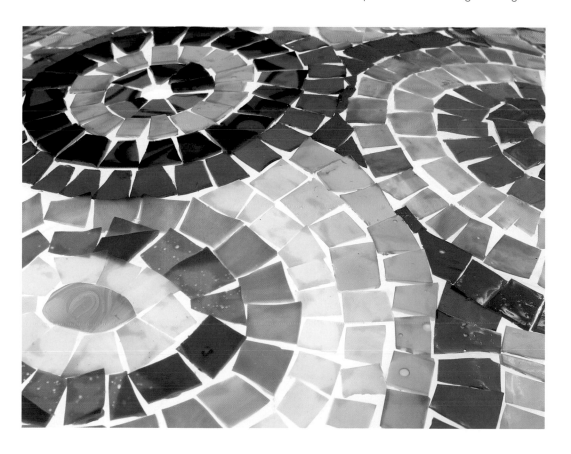

3 Continue in the same manner adhering tiles to the shade with gel medium until all of the mosaic tiles are fixed to the glass and the design is complete.

DECORATIVE OBJECTS

147

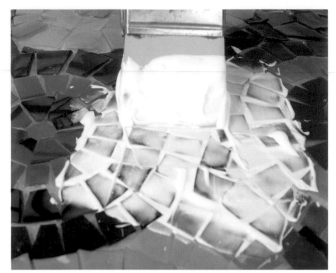

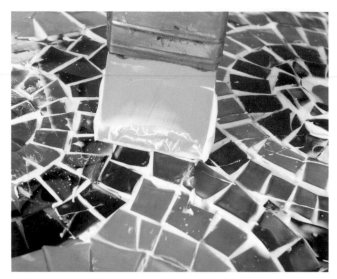

4 Mix titanium white with matte gel medium to make a clean white "grout." Apply the grout with a soft silicone-tipped tool, pushing the grout into the crevices between the tiles.

5 With the edge of the tool, scrape the excess grout from the tiled surface. On larger pieces, the grout must be added one area at a time, as it will dry if left too long on top of the tiles.

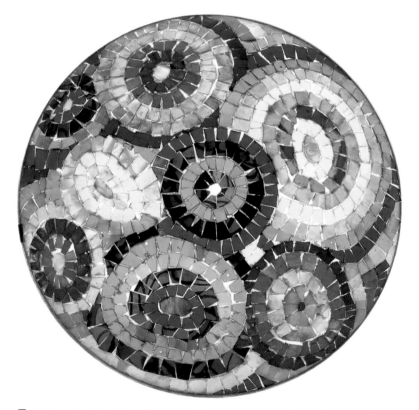

6 After filling in an area, rub any leftover grout off of the surface of the tiles (be careful not to remove the grout in the crevices between the tiles). Continue in this manner until all of the crevices between the tiles are filled with grout.

7 The finished shade. The mosaic is now ready to hang. As the gel holding the acrylic tiles will soften a little when heated, it is best to use mid- to low-wattage bulbs.

drip light

If this were a sewing pattern, this project would be in the "very easy" category. Simply pour and swirl acrylic paints in harmonious colors onto a clear glass cube lamp. When the paint is dry, the film clarifies, displaying a cool ambient light.

materials

- glass cube lamp
- liquid acrylic colors: blue, green
- self-leveling gel medium
- palette knife

1 Tint the gel medium with the acrylic colors. Use your palette knife to apply the first drops of color. While the first drops of color are still wet, begin pouring the top color.

2 Pour the color in thick slabs, covering the whole top plane of the cube. Continue adding tinted gel so that it overflows and spills down the sides, covering the lamp with an even blanket of color.

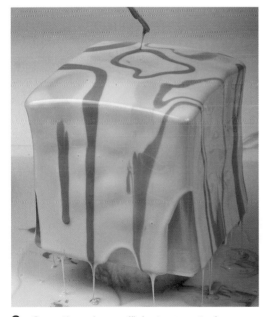

3 Once there is a sufficient amount of medium down the sides of the cube, drip and swirl the next color on top. Work quickly to keep up with the flow of the medium. The colors will blend as the gel dries.

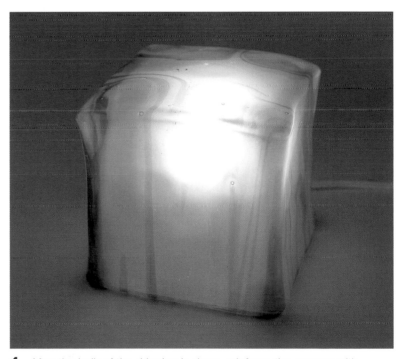

4 After the bulk of the dripping is done, reinforce the corners with one last blob of paint. As the gel drips off the cube, use the side of the palette knife to trim off the excess. Let the paint dry for 24 hours before using the lamp.

materials

- frosted glass table lamp
- matte gel medium
- gloss gel medium
- acrylic colors: opaque cream, green, rust, bronze
- non-adhesive acrylic palette
- acrylic transfers (see page 122)
- acrylic topcoat
- pastry applicator with small round tip
- assorted paintbrushes

transfer lamp

Color is often at its best when infused with light. Fashioning a lamp from acrylic transfers and deep luscious glazes can transform a dull corner into a kaleidoscopic, cozy realm.

1 To begin, I made four copies of the photograph below by Grace Paulionis on glossy paper using an inkjet printer and then transferred the image (see page 122) using matte gel medium. Photocopies and ink jet prints are ideal for the transfer process as the ink can be easily separated from the paper.

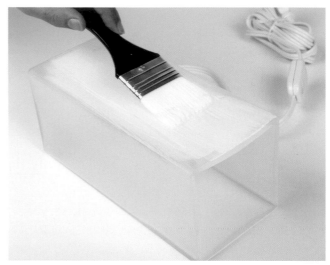

2 Apply a layer of matte gel directly to the sides of the lamp with a large, flat brush. Although this lamp is already frosted, the matte gel will further aid in softening the light glow.

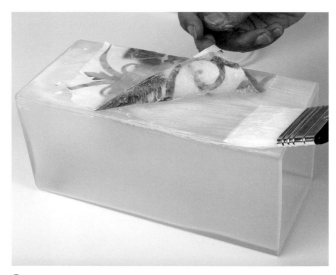

3 Lay the transfer on the gel, smoothing the gel down so as not to leave lumpy areas underneath. Repeat to apply transfers to all four sides of the lamp.

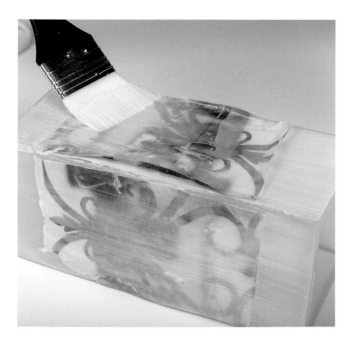

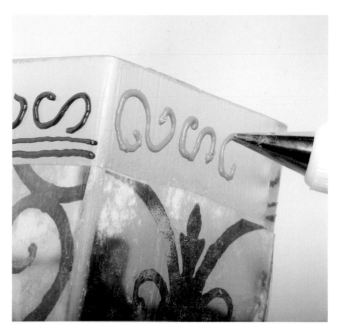

4 After the initial adhesive layer is dry, cover the transfer and surrounding area completely with a fresh coat of matte gel medium. Use long, uninterrupted brush strokes going from the bottom to the top edges of the lamp.

5 Detail the bottom and top edges of the lamp in a design fitting the style of the transfer. For this project, a pastry applicator was used to add bronze-colored relief detail. (See page 94 for more on extrusion.)

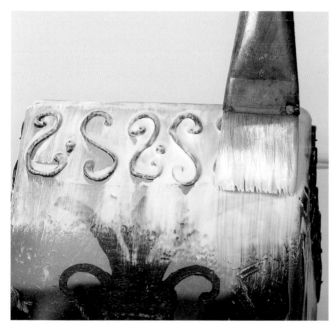

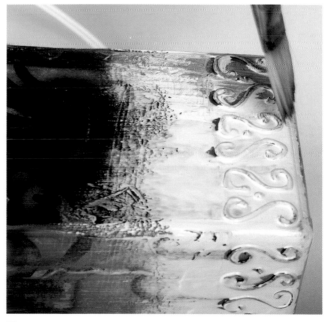

6 Paint over the lower portion of the lamp with opaque acrylic color. The color will help to diffuse the light and guide it gradually away from the bottom of the lamp.

7 Once the first paint layer is dry, paint over the area with colors corresponding to the ones found in the photo transfer. This will help to further unite and harmonize the decorations.

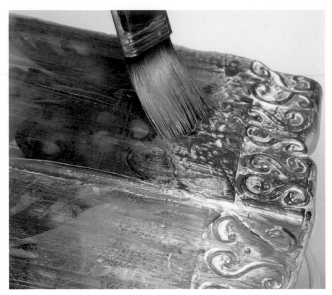

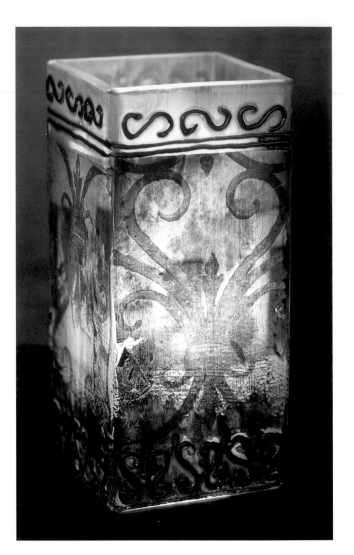

8 Brush a thin layer of the deeper rust and bronze tones over the extruded area to further bring out the textural detail and give the lamp an aged patina.

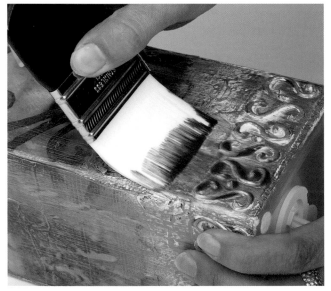

9 To protect the lamp from dust, apply one layer of tinted or clear topcoat or varnish.

made in the shade

Lamps with fabric, parchment, or plastic shades can also be used in this type of project. Instead of using a prefabricated shade, try making one yourself from a fire-resistant, translucent material. If you are unsure as to whether or not your chosen material can withstand the heat of a low-watt bulb, seal the inside of the shade with a layer of acrylic matte medium.

10 The finished lamp.

DEMONSTRATION 10

keepsake box

Distinctive boxes, frames, and tiles add an artistic tone to the aesthetics of an interior decor.
For this demonstration, I decorated a prefabricated basswood box purchased from my local
craft store. Objects constructed from MDF (medium density fiberboard) are quite suitable for
this type of application as the board is very rigid and has a uniform smoothness that absorbs
paint evenly.

materials

- basswood box with lid
- palette knife
- assorted paintbrushes
- soft cloth
- medium-grit sandpaper
- hardware: hinges, screws
- feet: cabinet pulls and bolts
- decorative 1-inch ribbon
- satin-covered cushion pad
- glass bead
- liquid acrylic colors: sepia, interference blue, iridescent pearl, iridescent pale gold
- gloss liquid polymer medium
- gloss topcoat
- white acrylic gesso
- water

1 To prepare the box for painting, first
remove all existing hardware. Lightly sand the
surface to remove rough edges and burrs,
providing an even surface for painting.

2 To showcase the decorative grain of the
wood, apply a wash of iridescent pearl and
pale gold tinted with sepia as a base coat.
Alternatively, white or colored gesso can be
applied to decrease paint absorption into the
material and to provide a uniform base color.

3 Drip gesso from the tip of a
palette knife in a swirling pattern
onto the dried base coat to create
a delicate relief.

DECORATIVE OBJECTS

153

4 As gesso is generally fairly fluid, it must be applied to each surface in succession. Allow each side to dry completely before turning the box over and decorating the next side.

5 Lightly brush a wash of dark color over the relief, allowing the color to pool around the raised gesso. To discourage beading on the paint surface, add a small amount of polymer medium or flow-enhancer to the wash.

6 For subtle luster and to further bring out the pattern detail, lightly brush over the surface with modest quantities of interference or iridescent colors.

7 With a soft cloth, rub off any excess color to give the piece a more polished look.

8 Make a glaze of primarily gloss polymer medium with a touch of warm transparent color. Apply the glaze over the surface for added depth.

9 Apply a protective coat of gloss or matte varnish to reduce the light tack of the surface and protect it against dust accumulation and scuffing. (Applying several coats of gloss medium will produce a lacquer-like finish.)

10 To add details like ribbon, lightly brush on some polymer medium. Apply decorative ribbon over the medium, smoothing the ribbon in place.

11 Be careful to attach hardware after the painting is completed so as not to mar the surface of the wood or metal accessories with paint or varnish. This will give the box a cleaner, more sophisticated appearance.

12 Opulent accessories, like this sumptuous lamp-worked, Moretti ivory glass heart pull with sterling silver findings, by Canadian glass bead artist Connie Paul, complete the elegant look of this keepsake box.

13 The finished keepsake box.

closing thoughts

CAN ACRYLICS DO IT ALL? No, there can be no one medium that could encapsulate our creative expression, our imagination, however complete in its design. If one medium could solve every application dilemma, coat every surface, and eliminate all need for other art media there would be a dearth of physical tools left to challenge our creativity. The compulsion to solve the capabilities and find the boundaries of a given medium or process is part of what drives artists to surpass themselves artistically and technically.

Our present lives are so full of shortcuts and easy solutions that we often take for granted the materials we use, reacting with dumbfounded petulance when they don't fulfill our extravagant expectations. Acrylics have borne the brunt of modern impatience and, to date, they have been found to be the most adaptable medium scientists and paint manufacturers have yet to conceive of.

Modern technology has facilitated so many things in our daily lives, acrylics being but one product of those advancements. Their adaptability and ease of use have made them the most widely purchased paint in North America, and they are becoming increasingly popular worldwide.

Acrylics are the products of years of research and development aimed at providing painters with a material that is perfectly suited to the new generation of artists. In an age when actually having the luxury of time to paint is rare, what other type of paint would we want? With crowded homes and crowded lives, what could be better than being able to produce artwork without the worry of toxic fumes and poisonous, volatile mixtures that pose health and environmental hazards?

I love that I can tap dance on my paintings with hiking boots and leave no more than a little rhythm in my wake. Acrylics allow me to be prolific and adventurous. I can rework a failed project with a single coat of color, paint in my kitchen with the windows closed, and clean my brushes with nothing harsher than liquid dish soap.

To assume that the popularity of this medium is dictated by, and limited to, the needs of hobbyists and leisure painters is faulty. The number of serious artists using acrylic media has grown exponentially over the course of the last few decades as acrylics have matured into a remarkably sophisticated painting medium.

There will always be resistance from the traditionalists to accept the unmistakable rise of synthetic media; no good revolution can take place without opposition to give it fuel and offer up a means of comparison. However, the old, in this case, does not necessarily have to make way for the new. Acrylic paints may have been conceived of primarily as a replacement for oil paints, but as they come into their own it becomes increasingly obvious that they stand in a class by themselves—separate, unprecedented, and distinctive.

Acrylics are the product of synthetic chemistry, a sort of alchemy where base chemicals combine with the very latest in coatings and pigment technology to create a chemical soup that is more stable, more "pure" than anything that has come before it. Acrylics are not at the mercy of the inconsistencies of nature. Each of the raw materials and the lion's share of the pigments used in the manufacturing of artist acrylics have been created in the lab. As such, they are produced in accordance with an exact recipe and subject to quality control methods that rely on precision instruments and measurements, therefore each batch is kept within the established parameters of its standard.

Acrylic paints are by no means perfect, however neither are they complete in their evolution. This is the age of the upgrade, and from the looks of how far this paint family has come in the last half century, we can anticipate great things from its progeny.

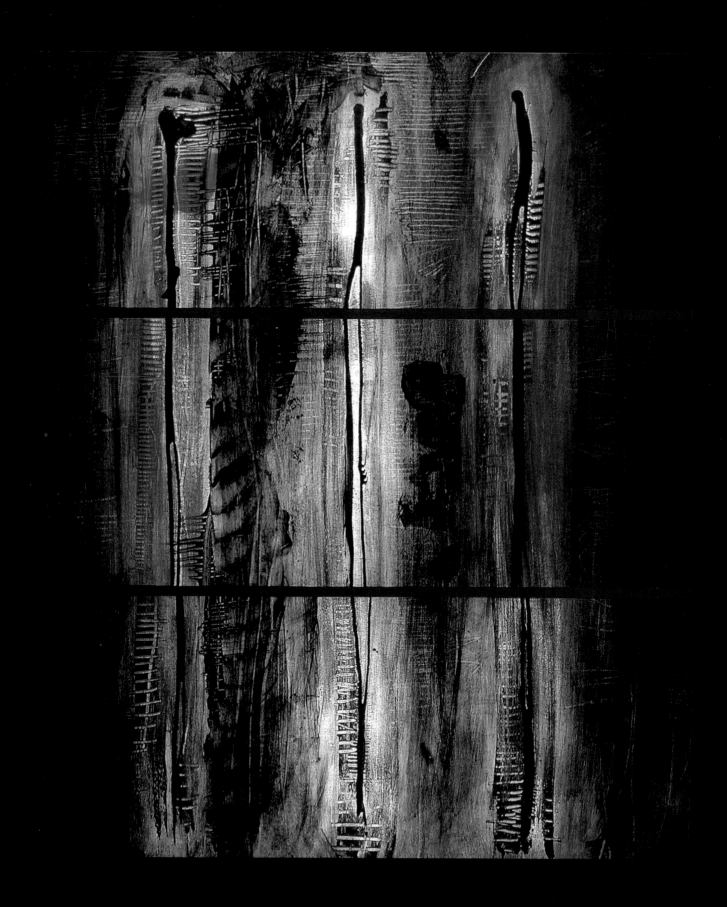

featured artists

The New New Painters group was formed in the 1980s and was formally launched in Paris (1992) by the international art dealer, Gerald Piltzer. New New Painters stand for life-affirming, personal expression. To quote from an early '90s New New Manifesto: "New materials demand a new direction . . . we are painting with pure plastic paint. We do not want to imitate oil paint . . . High Technology has given us a new world order and a new paint . . . no past material enabled us to substantiate the feelings of our time and formulate the vision and content of our lives . . ." Several books, catalogues, and many large exhibitions have celebrated New New Painting. Members of the group include: Lucy Baker, Joseph Drapell, Graham Peacock, Roy Lerner, Marjorie Minkin, Anne Low, Bruce Piermarini, Jerald Webster, Steven Brent, John Gittins, and Irene Neal.

recommended readings

Acrylic Painting Techniques, by Stephen Quiller. Watson-Guptill Publications, New York, 1994.

Arteffects, by Jean Drysdale Green. Watson-Guptill Publications, New York, 1993.

The Acrylics Book, by Barclay Sheaks. Watson-Guptill Publications, New York, 1996.

The Painters Handbook, by Mark David Gottsegen. Watson-Guptill Publications, New York, 1993.

www.handprint.com A great site maintained by Bruce MacEvoy with detailed information on pigments.

index